✳

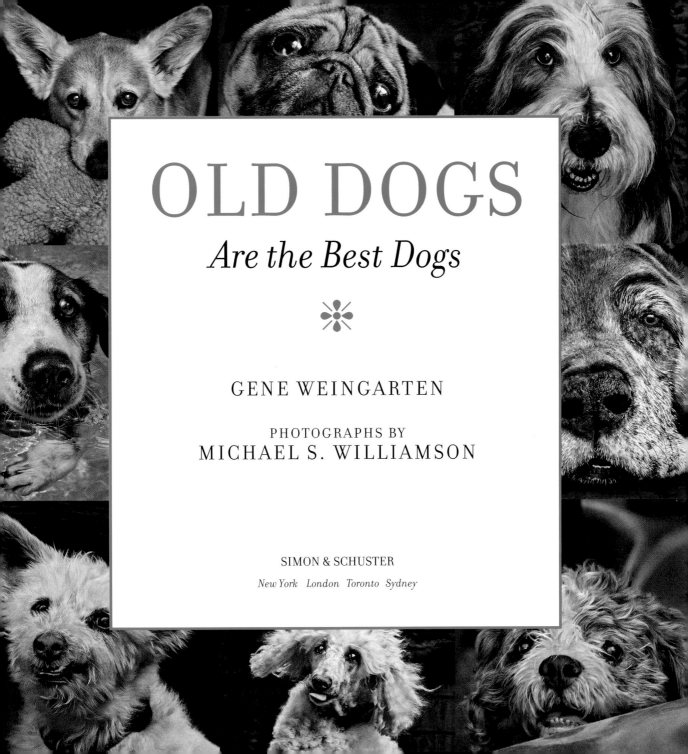

OLD DOGS

Are the Best Dogs

❈

GENE WEINGARTEN

PHOTOGRAPHS BY
MICHAEL S. WILLIAMSON

SIMON & SCHUSTER

New York London Toronto Sydney

Simon & Schuster
1230 Avenue of the Americas
New York, NY 10020

First Simon & Schuster hardcover edition October 2008

SIMON & SCHUSTER and colophon are registered trademarks of Simon & Schuster, Inc.

For information about special discounts for bulk purchases, please contact Simon & Schuster Special Sales at 1-800-456-6798 or business@simonandschuster.com.

Designed by Jaime Putorti

Manufactured in China

10 8 6 4 2 3 5 7 9

Library of Congress Cataloging-in-Publication Data

Weingarten, Gene.
Old dogs : are the best dogs / by Gene Weingarten ; photographs by Michael S. Williamson.
p. cm.
Includes bibliographical references.
1. Dogs—Anecdotes. 2. Dogs—Pictorial works. 3. Photography of dogs. I. Williamson, Michael, 1957– II. Title.
SF426.2.W35 2008
636.7—dc22 2007030303
ISBN-13: 978-1-4165-3499-0
ISBN-10: 1-4165-3499-7

※

To Brandy, Coffee, Penelope, Paco, Matthew, Molly, Sam, Augie,
Howard, Annie, Clementine, and Harry

✳

ACKNOWLEDGMENTS

We would like to thank Simon & Schuster publisher David Rosenthal, who heard the proposal for this book and, with barely a second's delay, opened his wallet. If you ask us, this is the epitome of a great American publisher.

We'd like to thank our editor, Amanda Murray, whose many fine suggestions improved the book in ways large and small; and our lawyer and agent, Arlene A. Reidy, who represented us ably and charged us nothing, owing to the fact that she is one of our wives.

We'd also like to thank Pat Myers, the world's funniest copy editor, who proofread this book as a favor even after we failed to include in it Henry, her gentle, estimable old dog.

Many people were extremely generous in helping us find the animals on these pages; among the most helpful was Melody Sarecky, who became something of a one-woman dog broker. Melody probably deserves a handsome finder's fee, but instead gets this handsome sentence of gratitude. Likewise, we thank the staff of Benson Animal Hospital in Bethesda, Maryland, in particular Nancy Miller and Marianne Katinas, through whose offices we located more than a few dogs. Doctors Albert and Randy Benson provided extraordinary veterinary care to Harry S Truman throughout his life. Harry's life is why this book happened.

No thank-you could be sufficient to explain the importance of Sophia and Valerie Williamson, who worked tirelessly for hundreds of hours as photo as-

sistants to their father. Sophia, 11, and Valerie, 8, proved intuitively skillful in the arts of dog wrangling, dog placating, dog distracting, dog entertaining, and dog loving.

And last, we thank the countless people who graciously permitted us into their homes to take photographs of dogs whose stories and faces did not make it into this book. For this omission we entirely blame the editors of Simon & Schuster, who, for reasons known only to them and for which they will no doubt have to answer in the Hereafter, balked at producing a 1,294-page book.

OLD DOGS

Are the Best Dogs

✻

This is a tribute to old dogs, a celebration

of their special virtues.

All dogs profiled in this book were at least 10 years old

when their portraits were made.

If you ask us which of them are still alive, our

answer is: They all are.

May old dogs live forever.

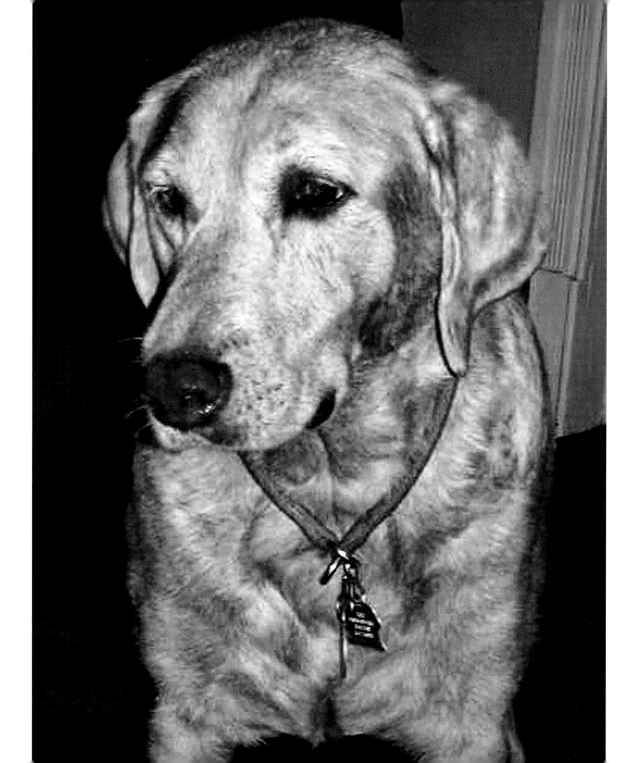

Remembering Harry

Not long before his death, Harry and I headed out for a walk that proved eventful. He was nearly 13, old for a big dog.

Walks were no longer the slap-happy Iditarods of his youth, those frenzies of purposeless pulling in which we would cast madly off in all directions, my back bowed, fighting for command. Nor were they the exuberant archaeological expeditions of his middle years, when every other tree, hydrant, or blade of grass held tantalizing secrets about his neighbors. In his old age, Harry had turned his walk into a simple process of elimination—a dutiful, utilitarian, head-down trudge. When finished, he would shuffle home to his ratty old bed, which graced our living room because Harry could no longer ascend the stairs.

On these walks Harry seemed oblivious to his surroundings, absorbed in the arduous responsibility of placing foot before foot before foot before foot. But this time, on the edge of a small urban park, he stopped to watch something. A man was throwing a Frisbee to his dog. The dog, about Harry's size, was tracking the flight expertly, as Harry had once done, anticipating hooks and slices by watching the pitch and roll and yaw of the disc, as Harry had once done, then catching it with a joyful, punctuating leap, as Harry had once done, too.

Improbably, unprecedentedly, Harry sat. For ten minutes he watched the

fling and catch, fling and catch, his face contented, his eyes alight, his ears alert, his tail atwitch. Our walk home was almost . . . jaunty.

❃

Some years ago, a humor contest in *The Washington Post* invited readers to come up with Item One from an underachiever's to-do list. First prize went to:

1. Win the respect and admiration of my dog.

It's no big deal to love a dog; they make it so easy for you. They find you brilliant even if you are a witling. You fascinate them, even if you are as dull as a butter knife. They are fond of you even if you are a genocidal maniac: Hitler loved his dogs, and they loved him.

Consider the wagging tail, the most basic semaphore in dog/human communication. When offered in greeting, it is a dog's way of telling you he is pleased with your company. It cannot be faked. It is hardwired, heart to tail, and its purpose is to make you happy. How many millions of dogs and how many millions of people had to love one another over how many millennia for that trait to have survived?

As they age, dogs change, always for the better. Puppies are incomparably cute and incomparably entertaining, and, best of all, they smell *exactly* like puppies. At middle age, a dog has settled into the knuckleheaded matrix of behavior we find so appealing—his unquestioning loyalty, his irrepressible willingness to please, his infectious happiness, his unequivocal love. But it is not until a dog gets old that his most important virtues ripen and coalesce.

Old dogs can be cloudy-eyed and grouchy, gray of muzzle, graceless of gait,

odd of habit, hard of hearing, pimply, wheezy, lazy, and lumpy. But to anyone who has ever known an old dog, these things are of little consequence. Old dogs are vulnerable. They show exorbitant gratitude and limitless trust. They are without artifice. They are funny in new and unexpected ways. But above all, they seem at peace. This last quality is almost indefinable; if you want to play it safe, you can call it serenity. I call it wisdom.

Kafka wrote that the meaning of life is that it ends. He meant that for better or worse our lives are shaped and shaded by the existential terror of knowing that all is finite. This anxiety informs poetry, literature, the monuments we build, the wars we wage, the ways we love and hate and procreate—all of it.

Kafka was talking, of course, about people. Among animals, only humans are said to be self-aware enough to comprehend the passage of time and the grim truth of mortality. How, then, to explain old Harry at the edge of that park, gray and lame, just days from the end, remembering, rejoicing, experiencing what can only be called wistfulness and nostalgia?

I have lived with eight dogs, watched six of them grow old and infirm with grace and dignity and die with what seemed to be acceptance. I have seen old dogs grieve at the loss of their friends. I have come to believe that as they age, dogs comprehend the passage of time, and if not the inevitability of death, certainly the relentlessness of the onset of their frailties. They understand that what's gone is gone.

What dogs do not have is a sense of fear or a feeling of injustice or entitlement. They do not see themselves, as we do, as tragic heroes, battling bravely against the pitiless onslaught of time. Unlike us, old dogs lack the audacity to mythologize their lives. You've got to love them for that.

❋

At the pet store, we chose Harry over two other puppies because, as he wrestled with my children in the get-acquainted enclosure, Harry drew the most blood. We wanted a feisty pup, and we got one.

It is instructive to watch what happens in a tug of war between a young boy and a young dog who is equally pigheaded but stronger. Neither gives an inch, which means that over dozens of days the boy is dragged hundreds of feet on his behind.

The product of a Kansas puppy mill, son of a bitch named Taffy Sioux, Harry had been sold to us as a yellow Labrador retriever. I suppose it was technically true, but only in the sense that Tic Tacs are technically "food." Harry's lineage was suspect. He wasn't the square-headed, shiny, elegant type of Labrador you can envision in the wilds of Canada on a hunting trip for ducks. Harry was the shape of a baked potato, with the color and luster of an interoffice envelope. You could envision him in the wilds of suburban Toledo, on a hunting trip for nuggets of dried food in a carpet.

His full name was Harry S Truman, and he had the unassuming soul of a haberdasher. We sometimes called him Tru, which fit his loyalty but was in other ways a misnomer: Harry was a bit of an eccentric, a few bubbles off plumb. Though he had never experienced an electric shock, whenever he encountered a wire on the floor—say, a power cord leading from a laptop to a wall socket—Harry would stop and refuse to proceed. To him, this barrier was as impassable as the Himalayas. He'd stand there, waiting for someone to move it.

Also, he was afraid of wind.

Harry was not the smartest dog I'd ever owned, but he was not the stupidest, either. That distinction will always belong to Augie, a sweet female collie who was not, to put it tactfully, Lassie.

Augie was infused with love for my then-toddler daughter and worshipfully watched her at play. At the swing set in our backyard, Augie positioned

herself in such a manner that, on every upswing, my daughter's shoes would whack her in the face. Clearly the dog knew this was not ideal, but she had no idea how to make the punishment stop.

When my wife went into a convenience store one day, she tied Augie to a large empty metal garbage can outside. When she came out, Augie was gone. My wife found her by following a trail of people doubled over in laughter, having witnessed the spectacle of a big dog running for her life, being pursued by a loud, booming, killer garbage can. The can chased her until she dropped from exhaustion.

Augie the collie lived to be 13 without ever, so far as I could see, formulating a coherent thought.

Harry was a lot smarter. He lacked the wiliness of some dogs, but I did watch one day as he figured out a basic principle of physics. He was playing with a water bottle in our backyard—it was one of those small-necked five-gallon cylindrical plastic jugs from the top of a watercooler. At one point it rolled down a hill, which surprised and delighted him. He retrieved it, brought it back up, and tried to make it go down again. It wouldn't. I watched him nudge it around with his nose until he discovered that for the bottle to roll, its long axis had to be perpendicular to the slope of the hill. You could see the understanding dawn on his face; it was Archimedes in his bath, Helen Keller at the water spigot.

That was probably the intellectual achievement of Harry's life, tarnished only slightly by the fact that he spent the next two hours insipidly entranced, rolling that bottle down and hauling it back up. He did not come inside until it grew too dark for him to see.

I think one problem with trying to assess the intelligence of a dog is that, with typical human chauvinism, we insist on applying our logic to their brains. This is a mistake.

Take Harry Truman and his relationship to the letter carrier. At mailtime, our haberdasher discovered within him the dark capacity to annihilate a city. He'd run to the front door, growling and snarling, and yank the mail in through the slot with his teeth in an effort to reach the beast beyond, and, if possible, kill him. To us, this seemed not only a ridiculous expenditure of energy and a futile spasm of hatred, but, above all, a lesson forever unlearned.

But think about Harry's logic. Over nearly thirteen years, on approximately four thousand occasions, he had confronted a stranger who was attempting to gain entrance to our home. Each time, because of Harry's diligence, the would-be evildoer was driven away. What's not to understand, or admire?

I believe I know exactly when Harry became an old dog. He was about 9 years old. It happened at 10:15 on the evening of June 21, 2001, the day my family moved from the suburbs to the city.

The move took longer than we'd anticipated. Inexcusably, Harry had been left alone in the vacated house—eerie, echoing, empty of furniture and of all belongings except Harry and his bed—for eight hours. When I arrived to pick him up, he was beyond frantic.

He met me at the door and embraced me around the waist in a way that is simply not reconcilable with the musculature and skeleton of a dog's front legs. I could not extricate myself from his grasp. We walked out of that house like a slow-dancing couple, and Harry did not let go until I opened the car door.

He wasn't barking at me in reprimand, as he might once have done. He hadn't fouled the house in spite. That night Harry was simply scared and vulnerable, impossibly sweet and needy and grateful. He had lost something of himself, but he had gained something more touching and more valuable. He had entered old age.

Some people who seem unmoved by the deaths of tens of thousands through war or natural disaster will nonetheless summon outrage over the mistreatment of animals, and they will mourn inconsolably over the loss of the family dog. People who find this behavior inexplicable or distasteful are often the ones without pets. It is hard for them to understand the degree to which a dog, particularly after a long life, becomes a part of you.

I believe I've figured out what this is all about. It is not as noble as I'd like it to be, but it is not anything to be ashamed of, either.

In our dogs, we see ourselves. Dogs exhibit almost all of our emotions, even the more complex ones; if you think a dog cannot register envy or pity or pride or melancholia, you have never lived with one for any length of time. What dogs lack is our ability to dissimulate. They wear their emotions nakedly, and so, in watching them, we see ourselves as we would be if we were stripped of posture and pretense. Their innocence is enormously appealing.

When we watch our dogs progress from puppyhood to old age, we are watching our own lives in microcosm. Our dogs become old, frail, crotchety, and vulnerable, just as Grandma did, just as we surely will, come the day. When we grieve for them, we grieve for ourselves.

The meaning of life is that it ends.

In the year after our move, Harry began to age visibly, and he did it the way most dogs do. First his muzzle began to whiten, and then the white slowly crept

backward to swallow his entire head. Pink nose, white head, tan flanks—he looked like a stubby kitchen match. As he became more sedentary, he thickened a bit, too.

I remember reading an article once about people in Asia who raised dogs for food. A dog rancher was indignantly defending his profession, saying that he used only "basic yellow dogs." As I looked down at Harry, asleep as usual, all I could think of was: meat.

But Harry's physical decline was accompanied by what I will call, at the risk of ridicule, a spiritual awakening.

A dog's greatest intelligence is said to be his innate ability to anticipate and comprehend human feelings and actions. It's supposedly a Darwinian adaptation—dogs need our alliance in order to survive. In earlier years Harry had never shown any particular gift for empathy, but as the breadth of his interests dwindled and his world contracted, he seemed to watch us more closely.

My wife, who is a lawyer, also acts in community theater. One day she was in the house rehearsing a monologue for an upcoming audition. The lines were from Marsha Norman's two-person play 'Night, Mother, about a middle-aged housewife who is attempting to talk her adult daughter out of suicide. Thelma is a weak and bewildered woman trying to change her daughter's mind while coming to terms with her own failings as a mother and with her paralyzing fear of being left alone. Her lines are excruciating.

My wife had to stop in mid-monologue. Harry was too distraught. He could not understand one word she was saying, but he figured out that Mom was as sad as he'd ever seen her. He was whimpering, pawing at her knee, licking her hand, trying his best to make things better. You don't need a brain to have a heart.

As a young dog, Harry petitioned for affection the way young dogs do—

aggressively, barreling in headfirst for a pat or a chuck under the chin. But in these later years he perfected what I call the old dog's hug. Old dogs back up to you, leaning in with an insistent wiggle until they cannot be ignored, coaxing a knead on the behind. I've never figured out what that is all about, but I've come to love it.

Harry was always miserably frightened of thunderstorms, but as he aged and his hearing waned, as if in a benign collusion of natural forces, this terror subsided. He became a calmer dog in general, if a far more eccentric one.

On walks he would no longer bother to scout and circle for a place to relieve himself. He would simply do it in mid-plod, like a horse, leaving the difficult logistics of drive-by cleanup to me. Sometimes, while crossing a busy street as cars whizzed by, he would plop down to scratch his ear. Sometimes he would forget where he was and why he was there. To the amusement of passersby, I would have to hunker down beside him and say, "Harry, we're on a walk, and we're going home now. Home is this way, okay?"

On these dutiful walks, Harry ignored almost everything he passed. The most notable exception was an old barrel-chested female pit bull named Honey, whom he loved. This was surprising because other dogs had long ago ceased to interest Harry at all, and even back when they did, Harry's tastes were for the guys. Though he was neutered, Harry's sexual preference was pretty evident.

But when we met Honey on walks, Harry perked up. Honey was younger by five years and heartier by a mile, but she liked Harry and slowed her gait when he was around. They waddled together for blocks, eyes forward, hardly interacting but content in each other's company. Harry reminded me of an old gay man who, at the end of his life, returns to his wife to end their time together on a porch swing under an embroidered lap shawl. I will forever be

grateful to Honey for sweetening Harry's last days. Hers is the first portrait in this book.

I work mostly at home, which means that during the weekdays old Harry and I shared an otherwise empty house. Mostly he slept; mostly I wrote and paced, and my pacing often took me past his lump on the floor. I would always mutter, almost unconsciously, "Hey, Harry," and he would always respond in the same fashion: His body would move not at all, but his tail would thud, exactly once, against the floor.

I didn't really know how important that ritual was until there was no thud anymore.

※

One night at three A.M., a smoke detector in our house began to bleep in that annoying, Chinese water-torture way, signaling that it needed a new battery. To us it was mildly annoying, but to Harry it appeared to be a sign of the apocalypse. He began pacing and panting and actually tried climbing the stairs to hide under our bed. His rheumy legs buckled; we caught him before he fell.

So I mounted a ladder, disconnected the bleeping thing, and took out the spent battery. Then my wife spent two hours talking Harry down into a semi-sane condition. She slept on the floor by his side.

It turned out to be Harry's final eccentricity. When he awoke the next morning, he could no longer use his hind legs at all, and we carried him off to the vet for the last time.

Harry timed his departure well. Had he waited a few more hours, my daughter would have been unable to hug him and tell him what a good boy he'd been. Molly had known and loved Harry more than half of her life, and I believe this was not incidental to her choice of career. On the

day after Harry died, Molly left town for her first day of veterinary school.

For nearly a week after Harry's death my wife and I shared a knowledge that we left unspoken, even to each other. It was simply too heart-wrenching to say out loud. As he lay on the gurney and the doctor began to push the poison into his vein, Harry had lifted up his head and kissed us good-bye.

Honey, 10

Shanna solemnly passed the butcher knife to Lance, her 16-year-old son. Shanna was a recent widow, Lance, the new man of the house. It was Lance who had brought home the stray.

Shanna had heard about this breed, particularly ones hardened by the streets, trained to do God Knows What. She knew of a test to find out if a dog is too vicious to keep. The test is not without risk.

"I'm going to give her some food," Shanna said, "and then I'm going to suddenly take it away. If she attacks me, you have to kill her."

Shanna put down the bowl. Lance gripped the knife, white-knuckled, wary . . .

They laugh about it now, nine years later. Honey the pit bull, as sweet as her name.

Winnie, 15, and Lucky, 10

Winnie, the cocker spaniel, is older and wiser, but Lucky, the bichon frise, has the guile. At strategic times, she'll go running to the front door, barking furiously. When Winnie plods over to investigate, Lucky doubles back to Winnie's food bowl.

But it's when they're working together for a common goal that Winnie and Lucky become Win-ky, a single-minded opportunistic entity of stealth and cunning.

"It's teamwork, like a pick and roll in basketball," says James. "You're walking though the house, and suddenly Lucky is standing there. So you move around her, and there's Winnie, so you slide left around *her*, and now you're over by the counter, right where they wanted you, right where the cookie jar is. And Winnie and Lucky, they're starin' you down."

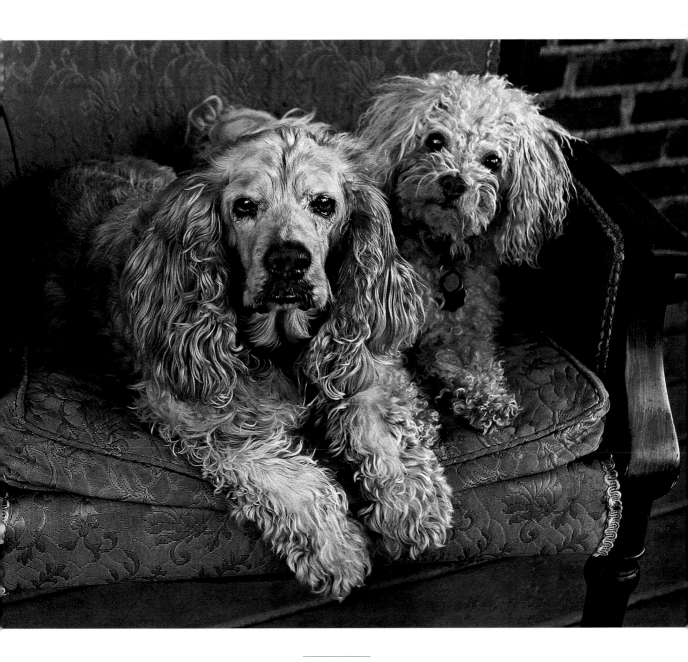

Stanley, 16

This is a breathtaking tale of yearning and desire, of daring and adventure, of the triumph of will. We're going to tell it in two hundred words. Warning: It's R-rated.

When Stanley the Jack Russell terrier was young and handsome, he was chosen to sire a litter. Alas, Stanley had the enthusiasm but not the height to properly woo the lovely but comparatively statuesque Hayley. No coupling occurred.

And so was arranged a different sort of conjugal event, at a veterinarian's office. There, in Hayley's presence but without her cooperation, through the practiced hand of a medical professional, Stanley was induced to surrender that which was needed.

The following evening when Debbie returned from work, Stanley was nowhere to be found. On her answering machine was a message from the vet: Stanley was on the front doorstep, wagging his tail hopefully. He had somehow escaped a fenced-in yard and run two miles through busy streets.

These days, in his senescence, Stanley sometimes gets a little a little foggy about where he is and where he is going. He can get lost. But he'll never lose the nickname he's carried ever since his Grand Adventure:

Manly Stanley.

Lexi, 14

So what if Lexi slobbers? She may be a little careless, but that doesn't mean she's stupid.

Okay, she's also stupid. In the snow, Lexi never learned not to stand in front of a moving sled. She has been known to approach her food bowl with a Frisbee in her mouth and get confused about how to eat. So what?

"Lexi is sweet and loving and keeps us in stitches," says Barbara. "What more can you ask of a dog?"

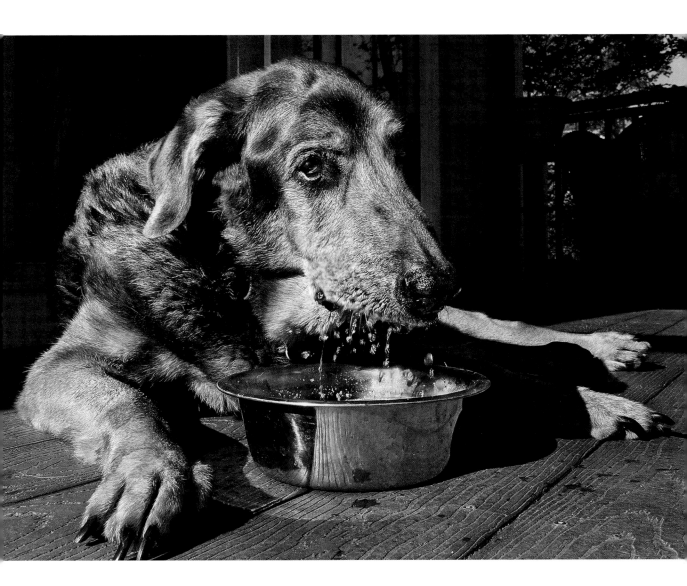

Skippy, 17

For Skippy, in the winter of his years, the days are largely indistinguishable. When he's not sleeping in his bed, he's snoozing on the old easy chair. He still goes on walks with Matt. He was never leashed; still isn't. He knows to follow Matt, 20 feet behind.

Skippy is mostly blind, but he still sees shapes. He'll often walk up to a tree and sit expectantly at its base, a good boy as always, awaiting instructions.

"He thinks it's me," says Matt.

Sometimes he'll walk in the wrong direction and Matt has to summon him back. "He can't hear his name anymore," says Matt, "but he hears a clap of the hands."

Skip is the same age as Matt's youngest, John, and they grew up close. But these days Skippy has a special affection for Paula, Matt's mother, and she for him. Paula is 80 and has a touch of Alzheimer's. At the table Skippy positions himself beside her. Paula keeps forgetting that she's not supposed to feed the dog, and the dog keeps forgetting he's not supposed to beg for food.

"It works out fine," says Matt.

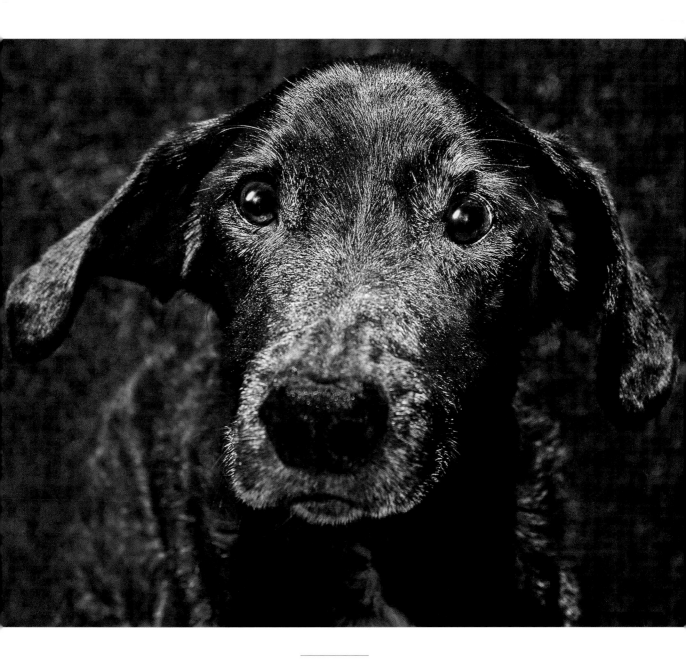

Oatmeal and Winston, 11

Oatmeal is pretty new to the house. He arrived as a Christmas present for the little girls.

Oatmeal is everything Winston is not. He's completely quiet, for one thing.

"Winston has a bark for the mailman," says Vicki, "and there's a different bark for the UPS truck, as well as a dog-walking-by bark, a stranger-at-the-door bark, a querulous bark, a Daddy's-home bark, a bark for 'please let me in the back door' . . ."

Unlike Winston, Oatmeal is reserved. Winston used to get his face between Vicki and her soon-be-husband, Dan, when they were making out on the sofa.

Unlike Winston, Oatmeal is sedate.

"When he was younger, Winston used to race from one end of the house to the other, top speed, and use the fireplace to launch a flip-turn," says Vicki. He's still pretty feisty. He still tries to herd people and raids the garbage and wants to kill the mailman.

So is Winston envious of Goody Two-shoes Oatmeal?

"They really don't interact much," says Vicki. "They've never been properly introduced in the way dogs get to know each other, because Oatmeal is always sitting."

Westleigh, 14

Extraterrestrial, you are thinking—a fine specimen of the mantis-headed quadrupeds of Alpha Centauri.

But that's just the look of the black-and-white photo. In real life Westleigh the whippet doesn't resemble an alien at all. He resembles a hoofed ruminant.

"Strangers have come to our door," says Janet, "to inform us that we have a deer in our backyard."

Westleigh is a sweet dog with an even, unassuming temperament. How even and unassuming? One day, as Janet walked into the house with a bag of groceries, Westleigh followed, the door banging hard behind them. It was not until a few minutes later that Janet's daughter noticed a great deal of blood. Westleigh hadn't made a sound. Apparently he hadn't wanted to make a fuss over something as trivial as a partially amputated tail.

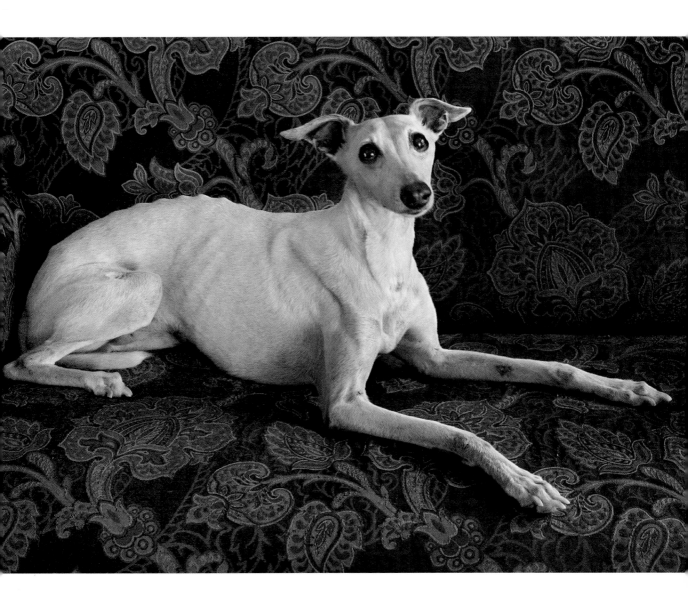

Smurfy, 17

Smurfy's bladder uncertainties arrived just about the same time Wren, the baby, did, so this family goes through a double dose of nappies. Wren, 18 months old, loves to chase Smurfy down and pull that thing off. "I think she sees it as a rodeo event," says mom Becky.

Back when her previous owners neglected her health and she almost died from heartworm, Smurfy had a different name. In her happy new home Becky wanted her to have a happy new name—but she also didn't want to confuse the dog. Murphy never noticed the change.

Smurfy has always been charmingly disobedient. Once she found open cans of beer Becky had half buried in the garden to drown slugs. Smurf ate the slugs and slugged the beer. She staggered home drunk and fell off the porch.

Sometimes even today, Becky looks outside and sees the tomato plants moving. That's Smurf, stealing her favorite meal.

"We have all these impromptu tomato plants from where Smurfy has scattered the seeds," Becky says. "After she's gone, those plants will be her memorial."

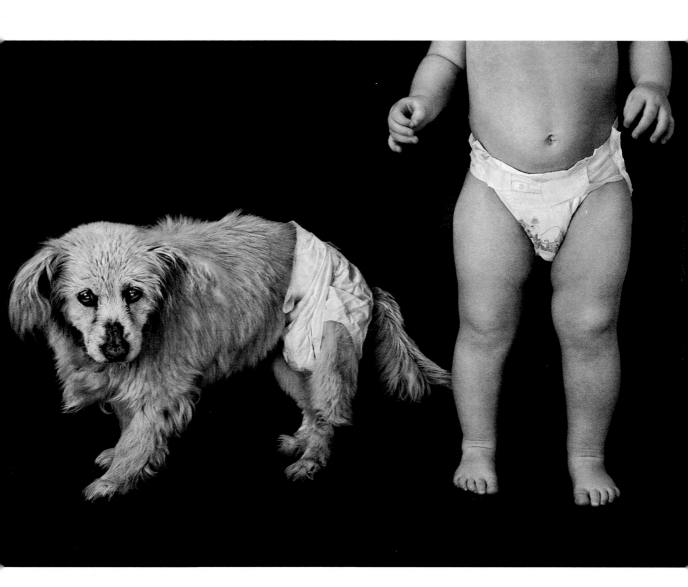

Star, 10

Instinct is a powerful biological force. It can be a funny one, too, when it persists long after its Darwinian need disappears. Suburban dogs still roll in decomposing slime to hide their scent from marauding tigers.

There is also the burying of food.

Star the beagle isn't outside much. Doesn't matter. She buries tortilla chips. She buries Toll House cookies. She buries bread. Because Star does these things furtively, Sharon discovers most of them by accident.

Where are these buried treasures? In furniture, in bedding, in anything soft and yielding.

"The other day," says Sharon, "I was emptying the laundry basket and out fell a pizza crust."

She looked at Star, plump and happy.

"I thought, *Where does this come from? She's old, but it's not like she lived through the Depression.*"

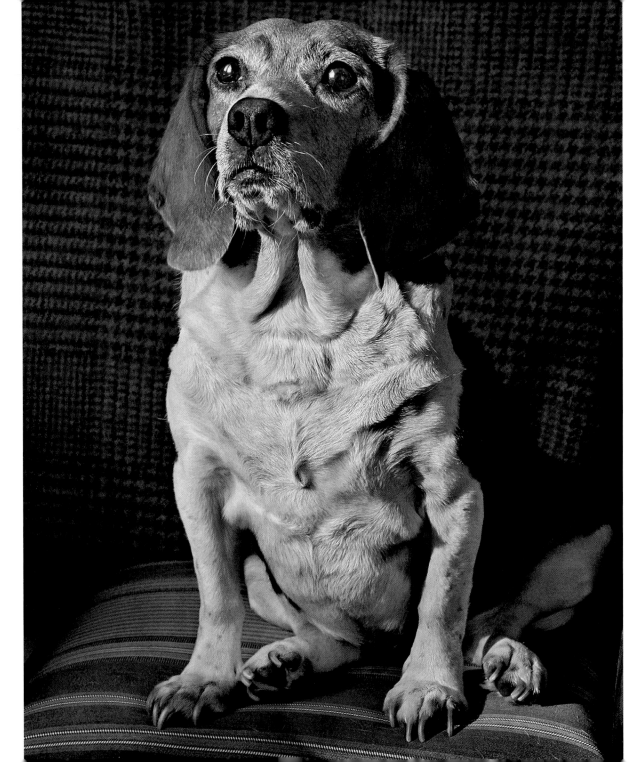

Rusty, 16

What you're looking at is a Pomeranian not much bigger than a fireman's fist, okay? Maybe you're thinking, *Aww, what a precious little sweetie.*

Yeah, and maybe you're a dope. Rusty lives in Baltimore. To protect his people, he has chased rats down alleyways.

Rusty once belonged to a motorcycle cop. The dog would sit in a basket in front of the handlebars, whipping through the city streets, fearless, nerveless, fur flying in the wind. Later, new owners tried to replicate the rush by putting Rusty in a basket on a bicycle. Rusty just yawned.

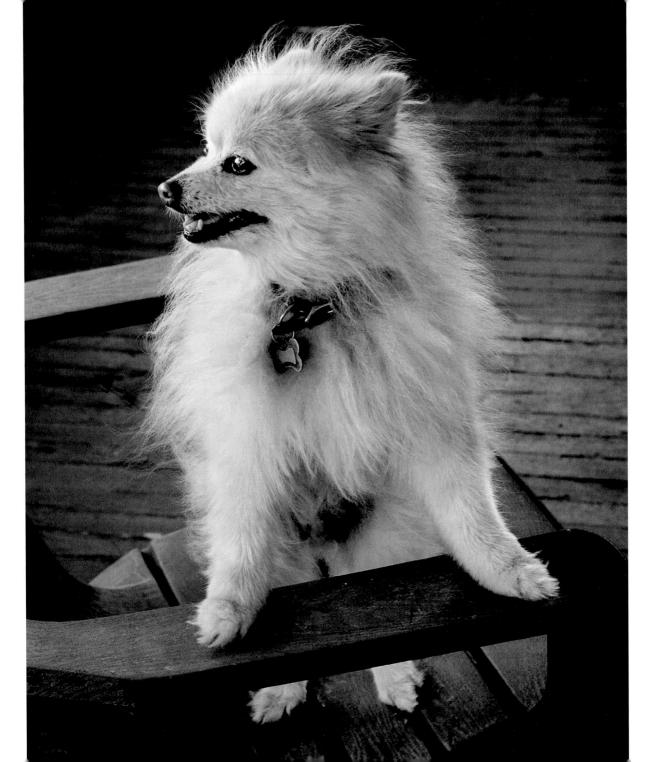

Chester, 11

Chester is a Pembroke Welsh corgi. He wants to herd sheep and cattle. His ancestry demands it. His genes compel it. Municipal statutes, alas, discourage the husbandry of livestock within city limits.

And so every morning when he awakens, Chester husbands his flock downstairs, eight of them, one at a time. There is the smiley man, Santa, big gingerbread man, little gingerbread man, purple teddy bear, Mr. Dachshund, the little bull, and mousie. Chester deposits them under the coffee table and then ignores them for the remainder of the day.

At night when Chester goes to bed, he herds his flock back upstairs, one at a time. There is smiley man, Santa, big gingerbread man, little gingerbread man, purple teddy bear, Mr. Dachshund, the little bull, and mousie.

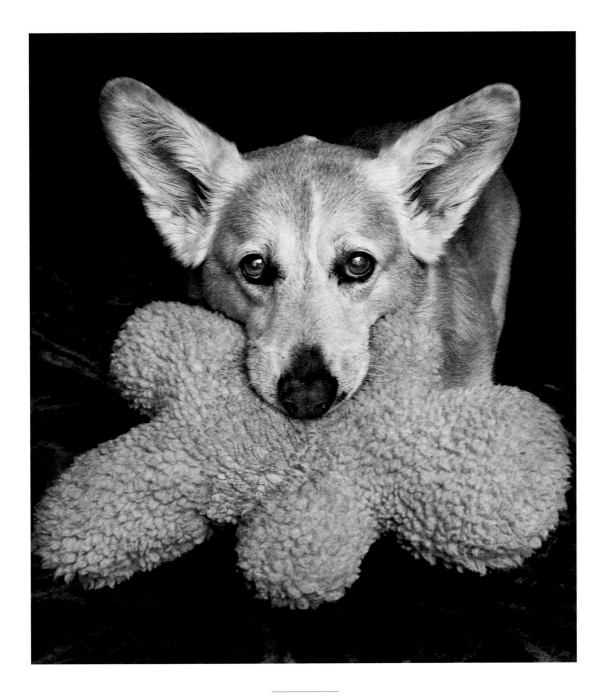

Blaze, 11

No fence could hold Blaze. Not chain link, not wire mesh, not wood slats or latticework. Can't leap over? Dig under. Doors? Don't make her laugh. You wait long enough, a door will open, and you're gone.

Lynda can't count the times Blaze escaped. "When she hit the street, she'd attack cars. She'd try to bite their tires and would bounce off."

Clearly something had to be done. So Lynda bought an electric fence. Stubborn as always, Blaze got herself seriously shocked several times before she learned. But Blaze is part border collie, and when she learned, she really learned.

The perimeter of her home circumscribes Blaze's world now, for better or worse. Lynda can't get her to go for a walk anymore. She tries. Blaze dutifully waits to be saddled up and allows Lynda to take her outside. But then she takes the leash in her mouth and leads Lynda back into the house.

At first Lynda feared the dog's spirit was broken. But then she understood: Blaze is still in control, still living on her terms.

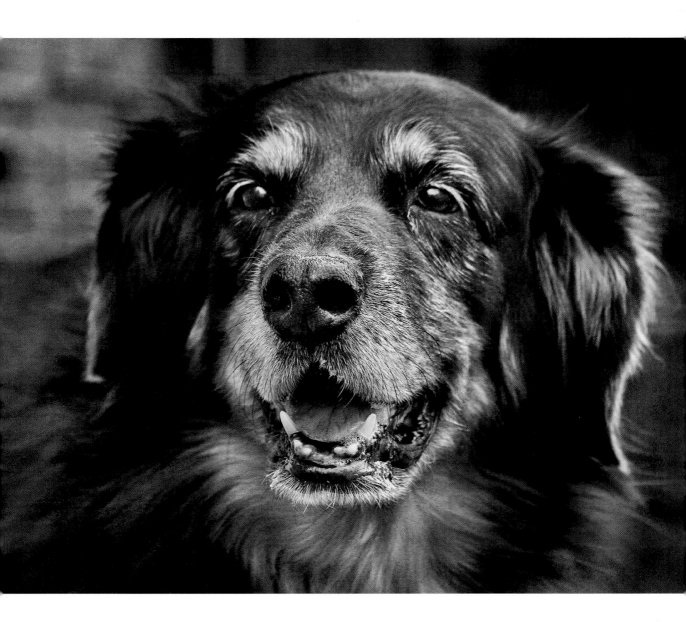

Heineken, 11

Pauline looked at the puppy's name on his cage in the pound and said to herself, *No way.*

She's not a snob; naming a dog for a beer was fine with her. But she had her standards, in dogs and in beer. So "Coors" went home with a more respectable name.

That's when the training began. Heineken the terrier mix flunked Fundamentals of Mailman Relations. He flunked Bath-Taking Etiquette. He flunked Fundamentals of Not Digging in the Garden. He flunked Respect for Sofa Cushions 101. So Pauline took him to obedience school. He flunked.

None of it mattered. Pauline learned to coexist with a good-natured dog with a mind of his own. "You gotta pick your fights," she says. "He wants to dig, he digs."

Pauline respects gumption. "Heineken's not a wimp. He's not weak."

Meaning, he's no Coors. Whew.

Lady, 17

Lady lives in an antique store in Austin, Nevada, with Alice, 79.

Listen to Alice:

"We used to have to be careful about what we put on the lower shelves because Lady was so friendly with the customers that she'd wag her tail and there would go some antique glass. Now she mostly just lays around. It's the arthur-itis.

"Lady's just a sweet lovable big ol' hound dog. She puts people at peace. Every time a priest comes in, he'll ask me, Would you like me to bless your dog? There's a spiritual man from the Western Shoshone reservation, he always says a prayer for Lady in Shoshone.

"Lady gets more lovin' than all the women in Austin. 'Course, there aren't that many women in Austin. It's two hundred and fifty people for a fifty-mile radius.

"One day a taxidermist comes in, he makes sure Lady can't hear and asks me if I wanted to have her stuffed. My goodness! We're not going to stuff her. Not going to bury her, either, the worms chewin' her up. Not for this dog. Time comes, we're going to cremate her, scatter her ashes in the desert, free and happy forever, like she deserves."

Walker, 10

Once upon a time in Spain there was a little bull and his name was Ferdinand. All the other little bulls he lived with would run and jump and butt their heads together, but not Ferdinand. He liked to sit just quietly and smell the flowers.

—Munro Leaf, *The Story of Ferdinand*

Once upon a time there was a little foxhound named Walker, who would not hunt. He was bred to hunt, but he had no taste for blood and loud noises scared him. If you want to know the truth, most everything scared him.

Because he would not hunt and kill, Walker was left to starve. Then nice people found him and nursed him back to health and put him up for adoption. That's how Susan got him six years ago.

"When he walked into the house," Susan says, "he was part of our family in fifteen minutes. He picked his spot, in a corner near the breakfast table, and that's where we put his bed and where it's been ever since. He doesn't like getting yelled at, so he's always a good boy. He's a fraidy cat, and we love him."

Belle, 14

There are three things you need to know about Belle.

1. She was once a real looker. She won a blue ribbon in a dog show.

2. Her eyeballs are white. Blind for eight years, she always wears sunglasses for photo ops. It's nicer that way.

3. She is the mother of the mayor of the town of Rabbit Hash, Kentucky.

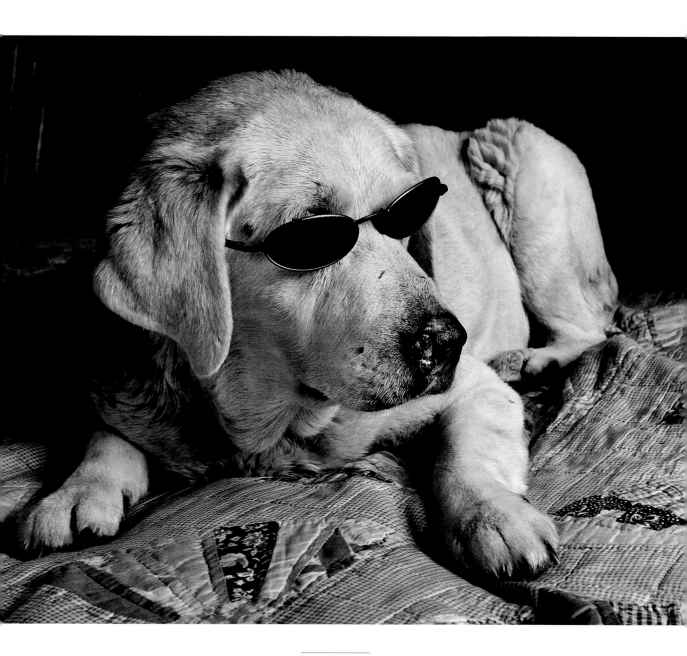

Sam, 16

There are three things you need to know about Sam.

1. In his younger years he was a fine bear hunter.

2. These days he's stone deaf and has a bum lower back, so he mostly just sits around, Sphinx-like. People think he's wise.

3. He's good friends with the mayor of Rabbit Hash, Kentucky.

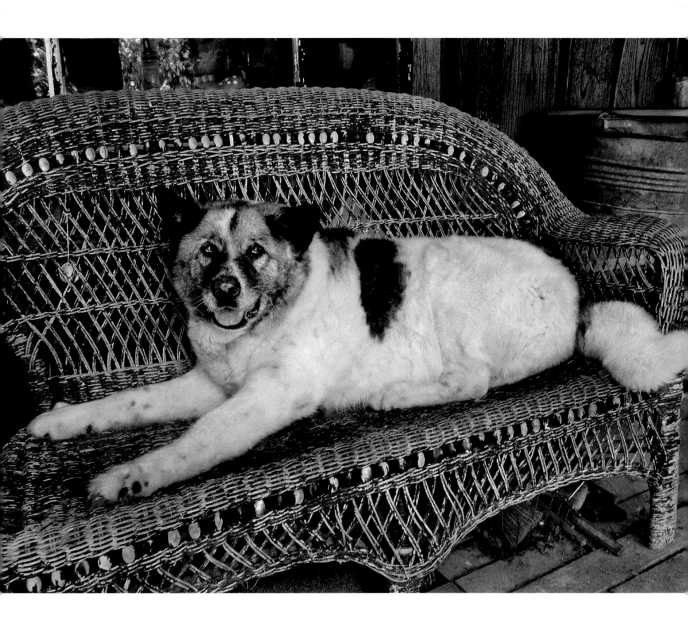

Junior, 11

Rabbit Hash, Kentucky, has a population of three. But if you include Greater Rabbit Hash, you're all the way up to about two hundred people. That's Junior's constituency. He's the mayor.

Some years ago, the citizens of Greater Rabbit Hash hatched up an unusual stunt to raise money for renovation of the local general store. "We did it like a good ol'-fashioned Kentucky election," says Jane. "You pay a dollar a vote, and whoever gets the most money gets to be mayor."

Some humans declared their candidacy, but—since there's no campaigning required and no official municipal duties to speak of—other candidates included a pig, a parakeet, a donkey, and more than one dog. Jane and her husband Randy raised $5,000 from friends and family, and their Junior got the job. It's a lifetime sinecure.

Is Hizzoner qualified?

"He's the most honest politician in the state," says Randy, "because he can't talk."

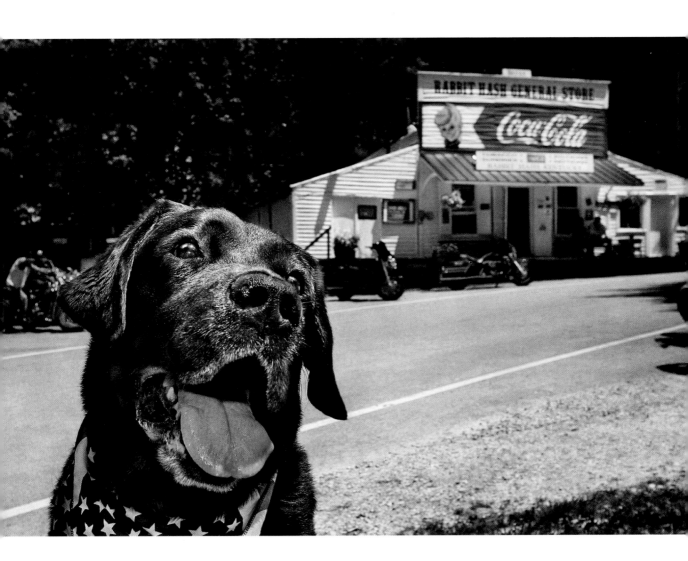

Little Dog, 10

When he was rescued from the pound, Little Dog was six years old and had been kicked around half to death—ears chewed up, teeth knocked out, a scar ringing his neck from where he'd been choked by a wire noose. To a dog like that, a killer hurricane's no big deal.

So when Katrina barreled into Pass Christian, Mississippi, on August 29, 2005, Little Dog huddled calmly with Alan and Clayton. They were one of the few families in town that tried to ride out the storm. Afterwards, their home damaged but intact, Alan ventured out, with Little Dog right behind.

"Every house around was gone," says Alan. "Not a stick above the slab."

That's when Little Dog surveyed the barren moonscape and learned the secret about what lay on the other side of Highway 90: a big beach.

You'll find him there most days now, prancing through the water and hassling seagulls. He's not allowed to cross that dangerous road, with the cars whizzing by, but he sneaks out and does it anyway. Then he returns at night, full of sass and sand.

"He makes it somehow—I don't know how," Alan says. "He's a survivor."

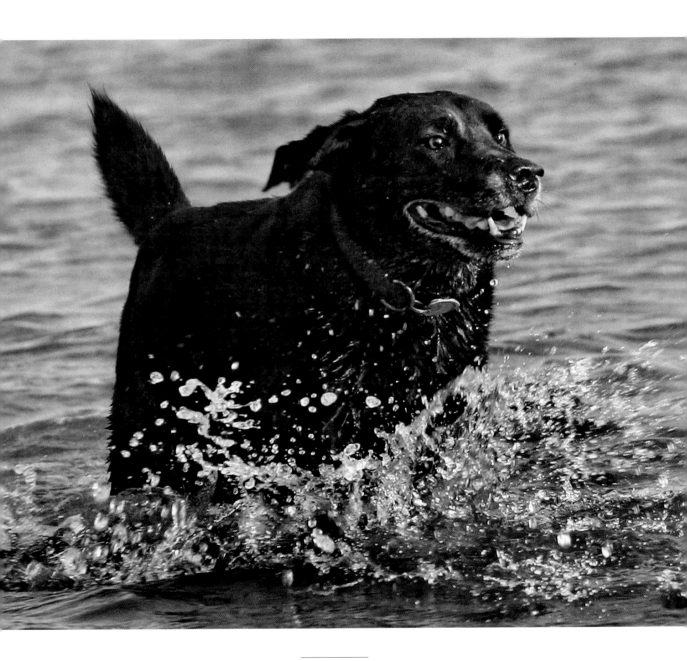

Cheyenne, 14

Heather can't tell you why Cheyenne still looks like a dog half her age. Maybe it's the outrageous anarchy of her eyes—one brown, one half brown and half blue. Maybe it's her diet: the raw carrots she learned to love from the horses she's been around all her life. Or possibly it's that she's never been bored. When Heather managed a horse ranch, Cheyenne rode shotgun on a John Deere. When Heather was a newspaper reporter, Cheyenne tagged along.

For two years, Cheyenne had a job of her own. In Vail, Colorado, Heather lent Cheyenne to the driver of a horse-drawn cab who had discovered that tips were much bigger when an affectionate, exuberant, furry little dog was on hand to supply foot-warming duties to chilly tourists. Cheyenne earned a dollar an hour, cash.

Now Heather and Cheyenne live on a twelve-acre farm. "She's still up every morning," Heather says, "to help me feed the horses."

Heather looks at Cheyenne with wonder.

"And she still bounces like a pup."

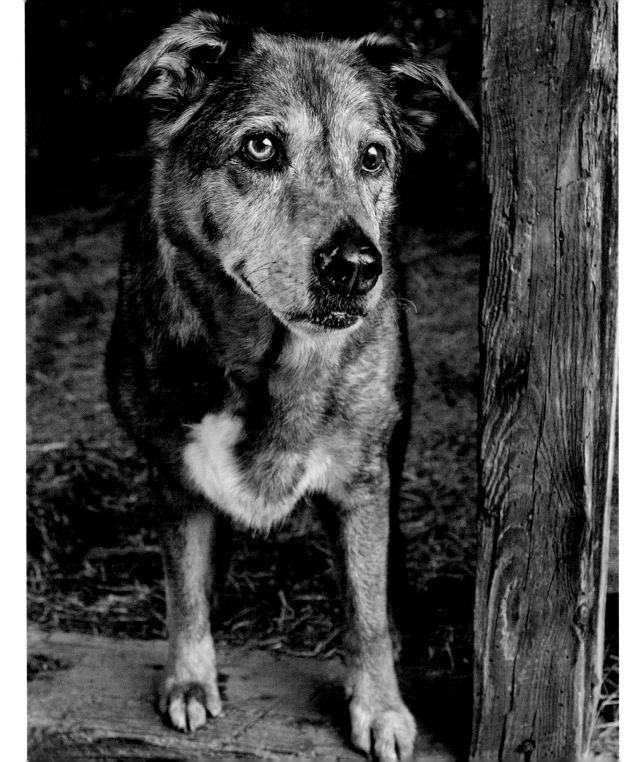

Ginger, 11

There are dog-dogs, and there are people-dogs, like Ginger. Because we cannot interrogate a dog, we cannot know if Ginger believes herself to be human, but she listens to dinner table conversation as though it were all directed at her.

"She'll cock her head when she hears a familiar word," says Elizabeth, "and she's always cocking her head, because there are a lot of words that are familiar." She's doing it right here, in the photo.

The hallmark of the people-dog is a preference for human family over canine friends and a disdain for the canine art of escape; a people-dog is completely content at home. That is why the family was stunned one day when they realized Ginger had bolted from the backyard. The gate had been left ajar.

A frantic hunt ensued. Finally Ginger was found. She was at the front door, waiting patiently to be let back in.

Hank, 11

What creates a dog like Hank?

He's a big dog. A good dog. A polite, obedient, undemanding dog. A dog with aristocratic bearing, but one who cringes and hides if someone nearby raises a hand or a voice, or even sneezes loudly. A dog who is aggressive with no one except other dogs whom he thinks might be threatening Eileen, her daughter Callie, or any of the three cats they live with. Hank guards with his life the family who adopted him when he was a year old, after he was found abandoned, chained to a doghouse.

Three years ago Eileen took Hank to the veterinarian. She finally asked about the tiny, hard lumps all over Hank's body, beneath his skin. The doctor pried one out with a scalpel, then another.

BBs. There were hundreds of them, in his belly, chest, head, and ears.

"Hank," says Eileen, "is the Dalai Lama, a dog with a gentle, perfect personality. And this dog," she says, still barely able to contain her anger, "was someone's target practice."

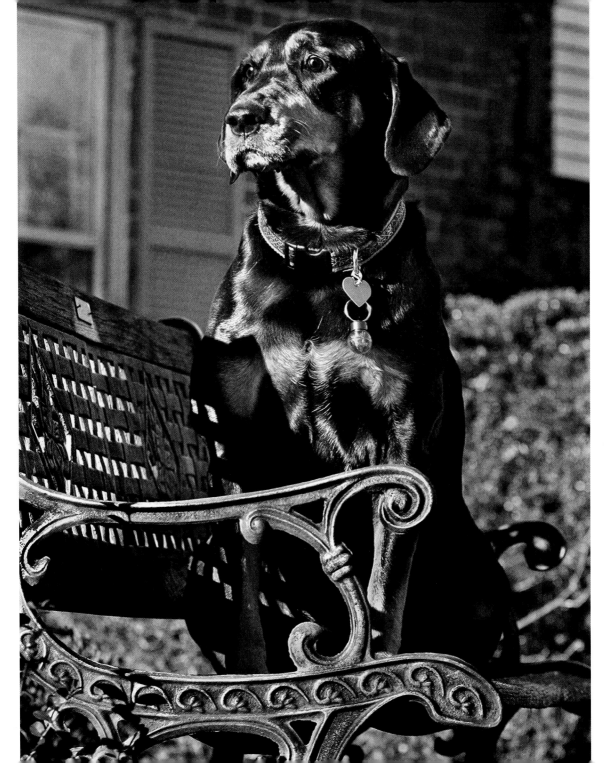

Spanky, 11

Ahab had Moby Dick, Captain Hook had his croc, and Spanky's got the nameless alley cat who took out his eye with the swipe of a paw. The eye's all cloudy now and not good for much. Damn cat still comes by from time to time to taunt Spanky, when he's out by the back door. Usually, though, Spanky's inside, watching Animal Planet on the big-screen TV that Janet always leaves on when she heads out for work.

Work can be bad, such as the time a man had a gun in a baby's mouth and was threatening to pull the trigger. Janet answers police hotline calls. When the day is done, she comes home to her only roommate and her closest friend.

"When I tell my family that *we're* going to do something," Janet says, "they know that *we* is Spanky and me. The two of us, that's enough for me. Because you look at this dog and you see compassion. There's compassion in that eye."

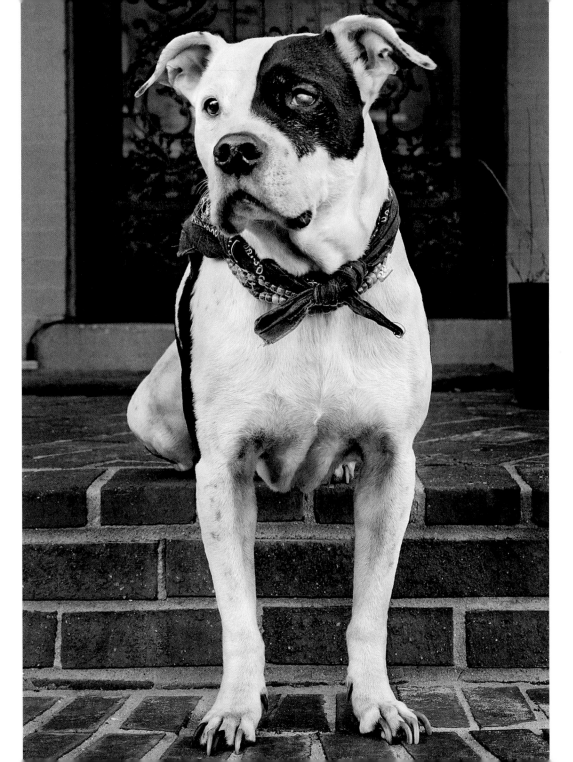

Boca, 10

Boca used to be a rhinoceros. That was back when she was dying.

The dog grew a three-inch tusk right between her eyes. The veterinarian said it was cancer, the worst kind, and told Patty to prepare to grieve. But during her divorce, Boca had been the only joint property Patty had been ready to fight over. She wasn't about to give up fighting.

Two years and $10,000 later, the tusk is gone. The vets keep Boca's photo in the radiology lab as a humble reminder that they aren't always right.

Boca is still the sage of the household. She still joyfully helps discipline the cats when Patty's mad at them. Yes, the radiation clouded her eyes and turned her black face into a photo negative, startlingly gray.

"I think she's beautiful," Patty says.

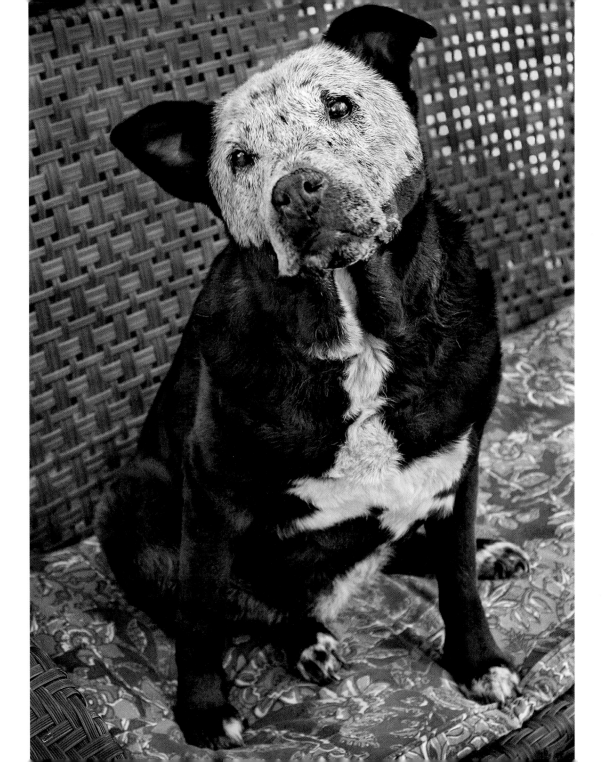

Bacco, 12

All dogs have a mission, some modest, some profound; some learned, some bred into their genes. Some retrieve. Some herd. Some race, some find things, some guard things. Some help the helpless. Some just look pretty.

Bacco eats balls.

He doesn't chase balls or retrieve balls. His job is purely epistemological: getting to the center of matters.

"He used to be able to carry two or three balls in his mouth at one time," says Elena. "He looked ridiculous, but he wasn't going to give up a ball to anybody."

As he gnaws, Bacco maintains a low, droning growl, like a woodworker's lathe. He has demolished tennis balls, Ping-Pong balls, soccer balls, tetherballs, baseballs, cricket balls, and softballs.

Elena's mom, Agnese, is a geologist. It is she who has studied Bacco's work most intently. She watched him at his greatest triumph, his masterwork—a golf ball.

"There are three or four strata," she says, "with plastic, then rubber bands, and cork at the center!"

Bacco met his match only once, with a regulation basketball he swiped from Elena.

"You could see him thinking, *I can totally do this*," says Elena sadly.

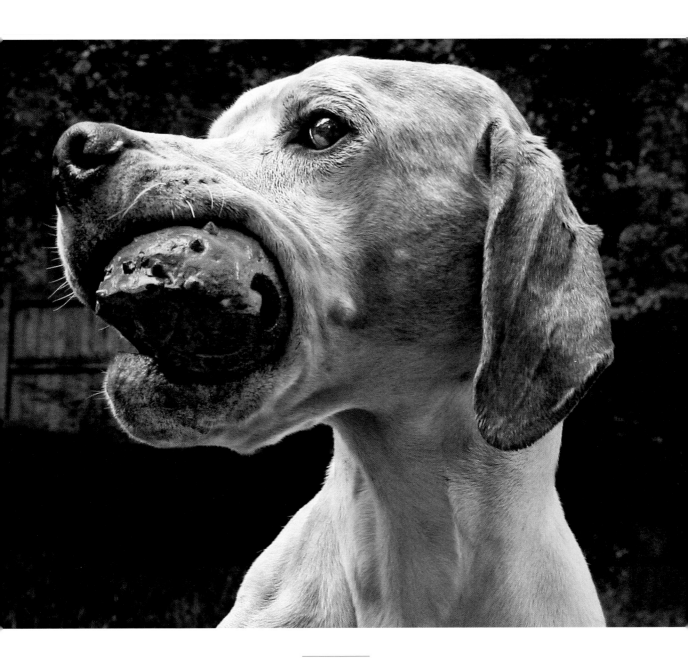

Fudge, 10

When you are a Brady Bunch dog, you learn to take things in stride.

It was a midlife blended marriage. Fudge came into it with Deborah and her two daughters. Jeff brought his son and daughter, some parakeets, and most inconsiderately, a pair of ferrets. This was a life form with which Fudge was bewilderingly unfamiliar.

Kids have ridden on Fudge, pulled her tail, yanked her ears, poked her eye. The ferrets treat Fudge like an exercise wheel. Fudge reacts to these indignities with studied nonchalance, just happy to be around people she loves.

"She's a mess," says Deborah affectionately. "She's on steroids because of ear infections and seborrhea and dermatitis that made her itch and smell awful. So now she's fat and always hungry."

This is Fudge at rest. Part doormat, part bearskin rug. Pure Fudge.

Sammy, 13

Before there was Sammy, there was Sparky. Mel was on a plane, weeping as she headed home from Florida after she and her husband had decided to divorce. *At least I'll have Sparky,* she consoled herself.

"When I got to the kennel," Mel remembers, "Sparky was in a Hefty bag." Heart attack. That's when Mel got Sammy. Sammy has not wanted for love.

Sammy may be regal in appearance, but she's a commoner. At home she gets the best of food, but her favorite treats are stale bagels and pizza snarfed up from the gutters on walks before Mel can pull her away. Sammy's a sheltie, low to the ground.

A pet psychic once told Mel that Sammy was mad at her because she wanted a rhinestone collar. That stupidity had Mel and Sammy laughing together, all the way home.

You think a dog can't laugh? Look at the picture.

Honey Pie, 15

"Aww, wook at the widdle baby in the stwoller."

"Wait. It's not a baby. It's a dog!"

"Isn't she just the *cutest*? Kitchee kitchee OW!"

Seven years ago Joe and Barbara got Honey Pie from a Chihuahua rescue group. The cage card warned: "Mean dog." It wasn't diplomatic, but it also wasn't inaccurate. Joe and Barbara came to love her, despite this.

For the last year Honey Pie has been too cranky and tired for a conventional walk, so she's wheeled around in a baby stroller. More than once, this has led to the scene above. "We haven't been sued yet." Joe laughs. "Most people get forewarned. When they reach in, Honey Pie gives them what we like to call her 'devil face.' It's all teeth."

Think you know Honey Pie? So did Joe and Barbara. Then one night the family cat, who was ill, crawled into Honey Pie's bed. Honey Pie never countenances incursions into her territory, particularly by the cat, for whom she held no affection. But that one time, dog let cat sleep through the night and stood guard protectively.

And yes, the cat died the next day. And no, no one has any idea how Honey Pie knew.

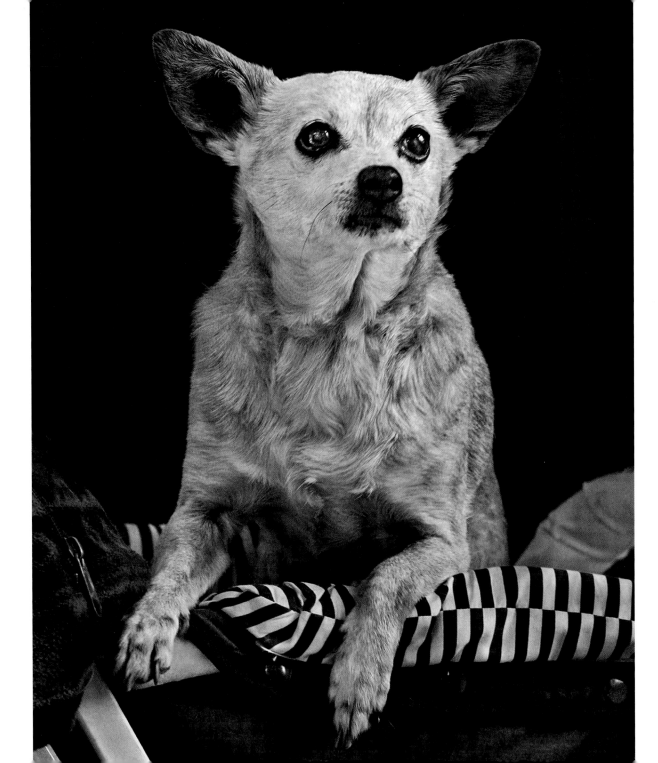

Caileigh, 14

"I think old dogs' faces show what kind of life they've had," says Patty. Patty works for a gerontological society. Her business is the science of aging.

"Caileigh's face has no scarring," Patty says. "It's a smooth face, a black-and-brown muzzle going white and gray, and her expression is hopeful.

"She has always loved long, adventurous walks in the woods and happy romps in the snow, and these things are no longer available to her. She can't hear me very well anymore, and she can't really see me, but look at her, here at my feet. She looks up at me with the same content face, the same loving smile she always had, and that's when I know that Caileigh is still there."

Patches, 14

They'd been dating for quite a while, so when Randy threw Sally an elaborate surprise birthday party, with a large guest list and taped greetings from old friends, Sally figured something was up. And she had a pretty good idea what it was.

So during the party, when Randy said theatrically, "Get ready for the next stage in your life," Sally sensed what was coming. She was going to say yes. She loved this man.

"And then," Sally recalls, "he brings out this *dog*, with balloons tied around her collar . . ." (She surreptitiously checked the collar, just in case there might be a ring there.)

That was thirteen years ago, the day Sally met Patches.

The ring happened a few months later, then the marriage and the kids, and always there has been Patches, the marble-eyed, big-hearted Cavalier King Charles spaniel. It's that heart that's giving out now. "We've passed five thousand dollars in vet bills," Sally says, "but Randy doesn't know that. Don't tell him."

Don't *tell* him?

"Okay, you can tell him. He knows how much I love this dog. And I know how much he loves me."

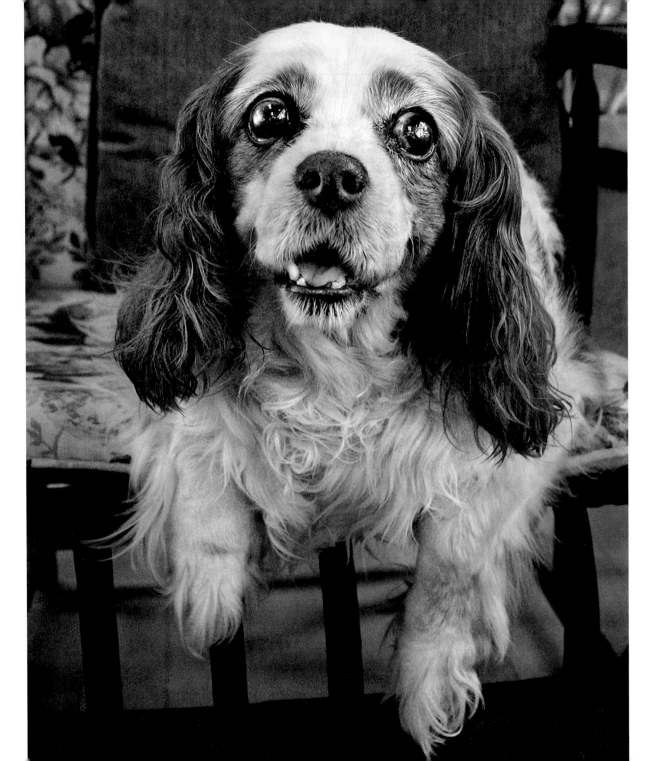

Emma, 10

Emma has spent about half her life at the vet.

There's nothing wrong with her health. Emma belongs to Nancy, who manages a busy suburban veterinary practice. The toy poodle goes to work with Nancy every day, where she is caged. Emma doesn't mind cages. All the animals are caged, and, like comrades in a cell block with a common gripe, Emma has happily bonded with thousands of dogs and cats over the years.

Those are some of them, behind her. Nancy takes a snapshot of every new patient and assembles the photos into massive collages that line the walls.

Emma knows two cool tricks. If you cock your finger at her and say "Bang!" she flops onto her back, legs in the air. (Nancy did not teach her the less genteel version of this trick: A female dog of our acquaintance does the same backflop when asked, "Now, how do we pay the rent?")

It is her second trick that most defines Emma, the veterinarian's office mascot. When she begs for a treat, she doesn't bark. She sneezes.

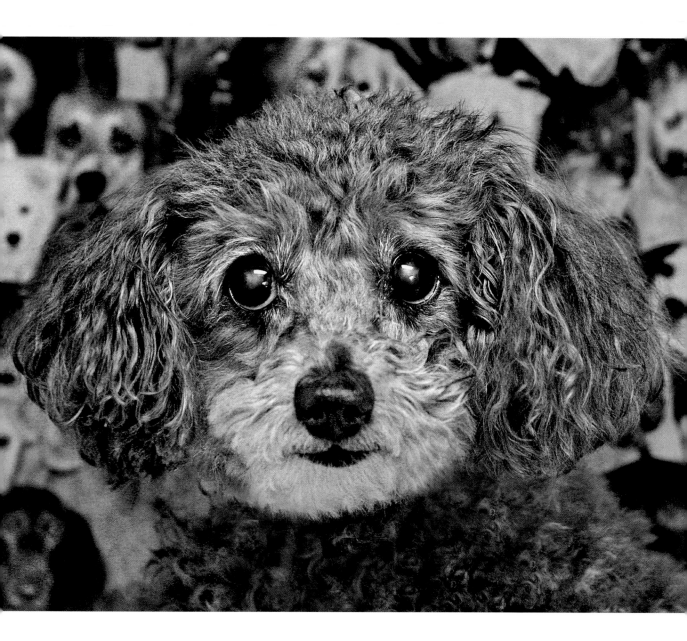

Ch. Pagan Place
Von Duesenberg, 14

How about we just call him Bumper, like everyone else does?

There was a time when Bumper didn't look like Phyllis Diller. He looked sillier. He was a standard poodle show dog, meaning he was that burlesque of canine topiary, with the naked heinie, the pom-pom tail, and the shaved face.

Bred by the wife of an automotive executive, his littermates included a brother named Rolls-Royce, another named DeLorean, and a sister named Jeep. Bumper's nickname is not a variation on a theme: He got it because he liked to goose people from behind. Bump.

Bumper the purebred prankster is blind now. When nature calls, he barks once and Janice leads him outside, his head still high, his step still confident, with Janice's hand on his ear to guide him. It's a reversal of sorts; in the show ring, the human follows the dog.

Bumper's still a patrician. He's like one of those ancient, silver-haired U.S. senators, still dignified, still erect of bearing, still oozing charm.

"An old politician isn't a bad analogy," says Janice. "He's still interested in the girls."

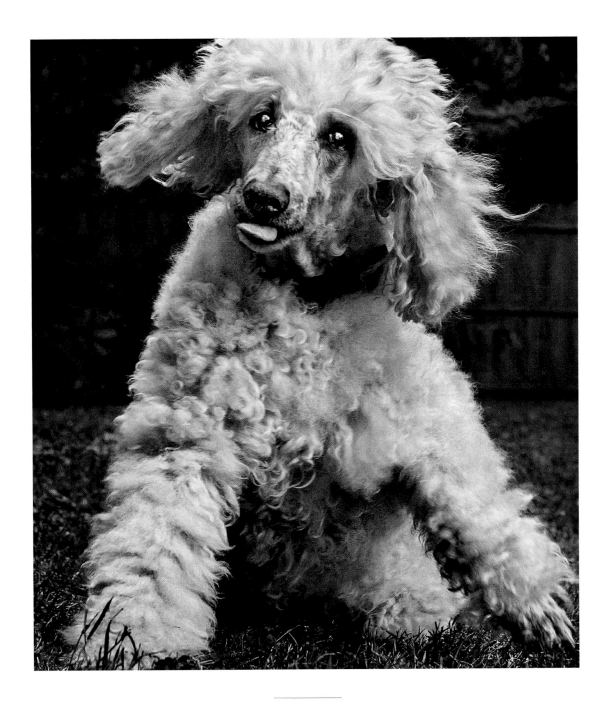

Golda, 14

By breed, Golda is a Cardigan Welsh corgi. By proclivity, she is a Tennis Ball Hound. A Yellow Fuzzmouth Retriever. Fetchy McFetchfetch.

Tennis Ball Hounds are unacquainted with the concept of ownership; unaware of the crime of larceny; invulnerable to distraction; disinclined to negotiate. When Golda was more fleet of foot, she couldn't be allowed anywhere near a tennis court lest havoc ensue.

At the dog park, with a ball in the air, Golda could outmaneuver a greyhound for his own ball in flight. She's got that intuitive Tennis Ball Hound's genius for understanding the physics of fetch: vectors, arcs, angles of incidence, angles of reflection, carom, torque, slickness of terrain.

Golda has slowed some. But she'll still haul out the ball, drop it at your feet, and backpedal away, rump raised, head down, focused on the ball, with that familiar growly plea. C'mon. C'mon. Just one more.

C'mon.

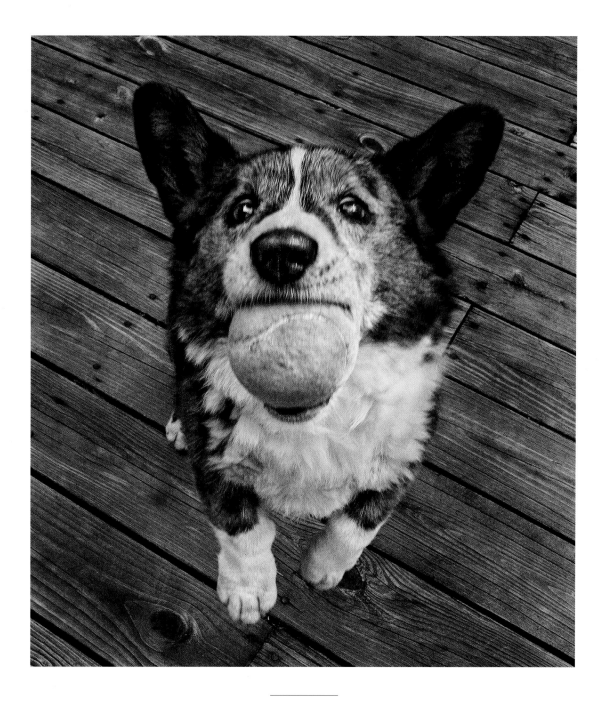

Chelsea, 13

You think *this* is cute?

It's nothing compared to this:

Some years ago in Scott and Denise's backyard in Indianapolis, a robin's nest was attacked by a crow; only one little hatchling survived the carnage. Scott and Denise nursed it on sugar water and baby food. When it had finished eating, Chelsea would gingerly lick food off its beak.

The bird slowly grew robust and big enough to drink from Chelsea's water bowl. Clearly it was time for the bird to leave.

Nobody explained that to the bird. It seemed content to stay with its new mother—that big, unthreatening dog. The robin followed Chelsea, inside and out, and nested in her paws when she was lying down.

"Just take the bird outside and it'll fly away," the vet advised. Nope. It just hopped down the driveway after Chelsea.

Weeks passed. One day Chelsea was outside, drinking, eyeing the little robin perched on the edge of her bowl. Denise watched in amazement as Chelsea lifted her paw and gently swatted the bird away. The robin took flight and never returned.

"I think Chelsea knew it was time," says Denise. "I think they both did. And that was that."

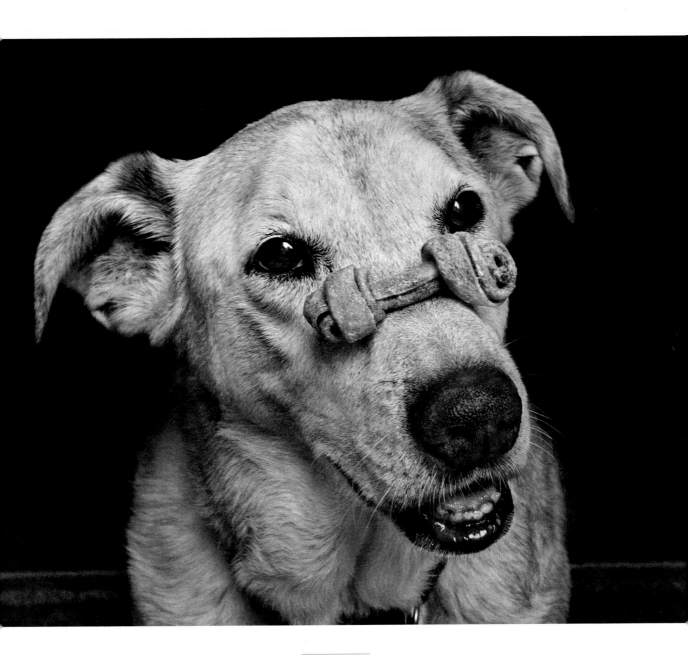

Zephyr, 11

Looks can be deceiving. It is true that in some ways Zephyr the Great Dane is your typical big lunk. She once spent an afternoon being taunted by chipmunks who were winning an impromptu game of whack-a-mole in the backyard. The rodents kept popping their heads out of holes and disappearing before Zephyr could galumph over.

But Zephyr is also the biggest house cat in America. She's easily offended. She's a little aloof. And she's also got a certain sense of . . . entitlement.

"She won't come to breakfast unless I phrase it a certain way," says Stuart. "I can't just yell, 'Zephyr! Breakfast!' She won't come. I have to say, 'Breakfast is now served,' or 'Will you be joining us for breakfast, madam?'"

And lastly, there is in Zephyr a certain undoglike imperturbability.

"Say we've been away on a trip three days," says Stuart. "When we get in, Zephyr won't bother to get off her bed to greet us. It's like, 'Oh, it's you.'

"You know what? We feel as though *we* live in *her* home."

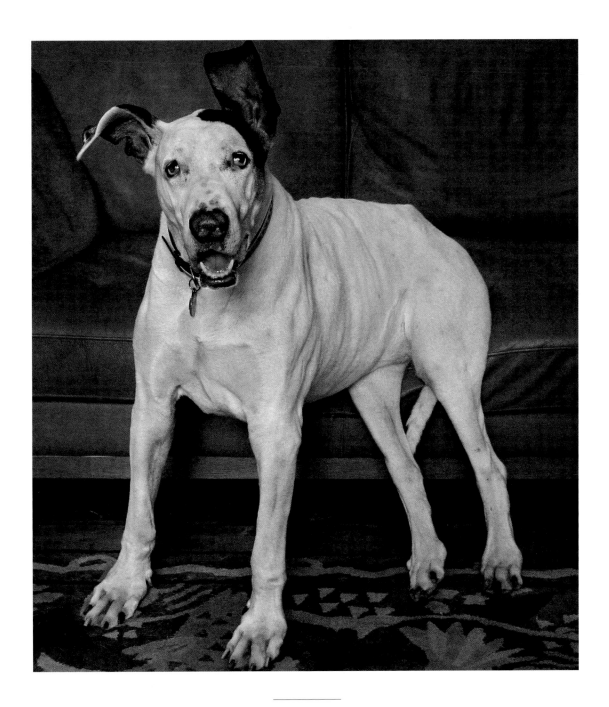

Boo, 10

Behold the wisdom of the ages, the countenance of one who has attained peace of mind and the ultimate enlightenment. Might a Solomonic face like this bear eternal truths?

Nah. Boo is seated on his Clifford blankie, with which he must travel so he doesn't feel insecure.

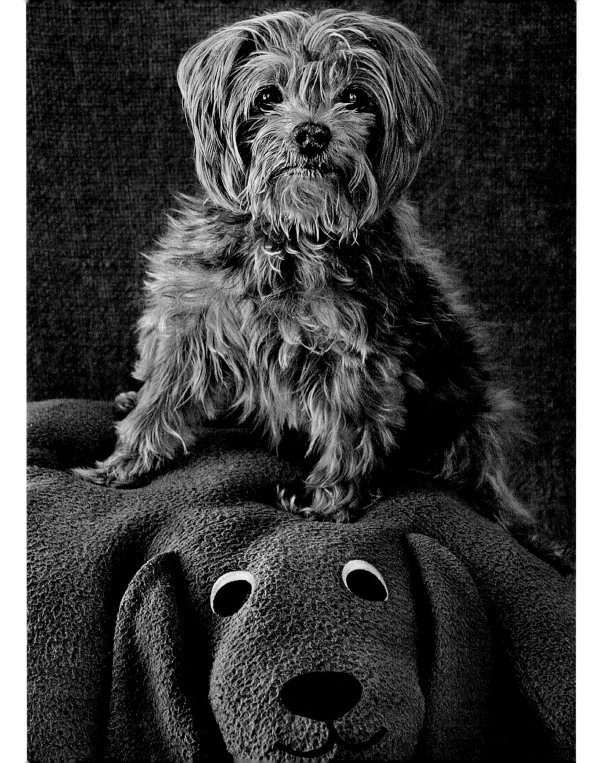

Nicole, 11, and Sophie, 11

Littermates Nicole and Sophie are part mirror images of each other and part photo opposites. They were abandoned as puppies at the door of a building superintendent in Manhattan's fashionable Murray Hill neighborhood. The super gave them to Susanna.

Among the dog owners of Murray Hill, there is a presumption of pedigree. In the street people would ask Susanna what breed her dogs were. After a while she got tired of telling the truth, which seemed to disappoint: Nicole and Sophie are "totally indeterminate."

"So I invented a breed," Susanna says. "I started telling people they were Latvian elkhounds."

We hereby declare Nicole and Sophie the finest examples of the breed we've ever encountered.

Sascha, 15

Even before he went deaf, Sascha never answered to his name. He was just ornery that way. So Jane's three teenage sons started giving him nicknames in the hope that one would stick. And thus it came to pass that Sascha also learned not to answer to Ninja, Coolie, Momo, Big Guy, Bear, Bobo, Moses, Pig Man, Skippy, and Crazydog.

There was one word, however, that always got Sascha's attention: "Food."

"Sascha loves food," says Jane. "Also pens and candy wrappers, and he is a big, *big* fan of Kleenex. It's amazing what you see come out of that dog."

Is there anything he doesn't eat?

"Stones," says Jane.

A sweet, gentle, goofy dog, Sascha has shown aggression only once in his life. That was the day that son Scott playfully put his face in Sascha's bowl and pretended to eat the dog's food. Scott did that exactly once.

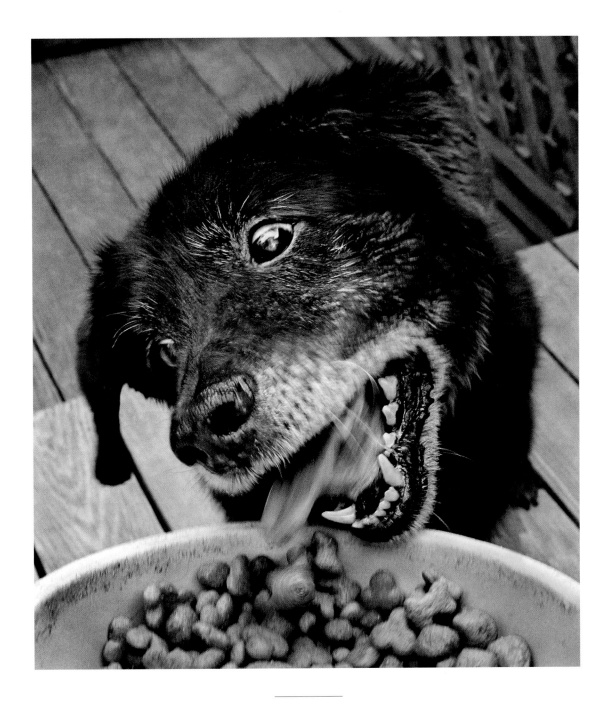

Blue, 14

There were two things that Lisa noticed about the 5-year-old dog in the cage at the pound. The first was that she looked feral, like a dingo. The second was that she seemed sad, like Lisa. Lisa suffers from depression.

The dog was a Texas blue heeler mix, which was poignantly misspelled on her cage. It said "Blue Healer." Lisa took her home.

"People with depression aren't supposed to have quiet dogs, they're supposed to have goofy dogs," says Lisa. "Well, that's not the dog I have. I have a beautiful, sweet-natured, pensive, melancholy dog who focuses on me and only me when I come home from work. She needs me. That's what I need." Lisa works in a hospice.

Blue's got cancer now. Lisa deals with end-of-life issues all the time, but she doesn't know how she is going to deal with this one. Like Blue, she's staying focused on her best friend. Lisa is also a massage therapist, so she spends nights making Blue's aching hips feel better. That will do just fine for now.

Buffy, 14

Anika and her family got Buffy as a puppy though an ad in *The Washington Post*. As if to return the favor, Buffy the cocker spaniel has appointed herself the family's paper girl. By Anika's calculation, she has brought in *The Washington Post* on 4,013 mornings.

"Even when she's tired," says Anika, "and she's tired more often now, this is the thing that perks her up. It's like she goes on duty. When we open the door, she shoots out like from a cannon. She sees it as her job." A cookie always awaits Buffy when her mission is completed.

"In the picture, you're looking at only part of the process," Anika says. "As she's trotting back into the house, she stops a moment and instinct takes over. She has to make sure she shakes the newspaper violently from side to side, to break its neck. Only then will she bring it in for us."

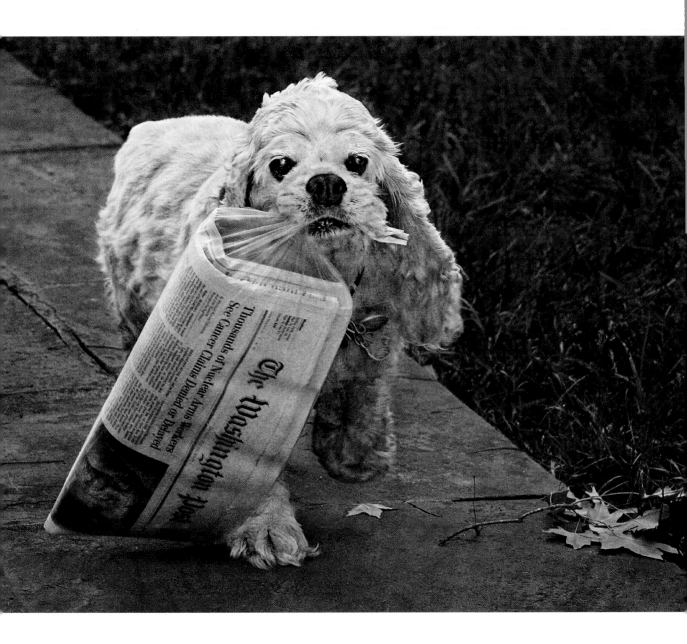

Kobi, 13

How is this dog like the Mona Lisa?

1. He just hangs out.

2. His eyes seem to follow you around the room.

3. People read a lot of different things into his expression. Some think Kobi's grumpy. Some think he's pensive. Still others think he's just completely placid and content.

We know the answer, but we're not telling. (Neither did Leonardo.)

Magic, 11

Samoyeds were bred to herd reindeer, which happen to be scarce in the sub-urbs. So Magic herds squirrels.

The philosophy of herding is to impel an animal that is in the wrong place—which Magic defines as the Earth's crust—to move to the right place, which Magic believes to be up a tree. This is Magic's mission, and he carries it out with extreme prejudice. He's a gentle dog, but not to squirrels.

One day during a walk in the park, Magic began to bark and paw at the ground. Then he ran to Rob, then back again to the same spot. Rob recognized this as your basic "Timmy falls into the mine shaft and Lassie summons help" routine. He went to investigate. On the ground at Magic's feet squirmed a baby squirrel, no bigger than a matchbox. It had fallen from a nest.

Rob popped the squirrel in his T-shirt pocket and drove away, Magic in the seat beside him, acting, for want of a better phrase, worried to death. They arrived at animal rescue and the squirrel was saved.

Would you believe Magic never again chased another squirrel? No, neither would we. He was back on rodent patrol the very next day.

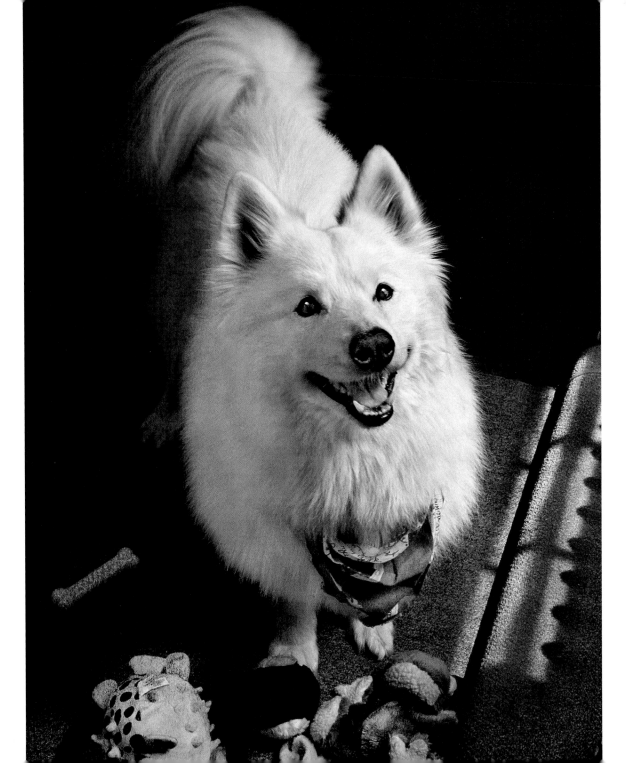

Figaro, 11

Perhaps you've read about Figaro, finder of corpses.

Figaro lives in Georgetown, the fanciest neighborhood in the nation's capital. He has had access to the finest veterinary care, which is why the melanoma on his jaw didn't kill him. It was excised through surgery and left him fine, but with a permanently flappy-floppy tongue.

Georgetown is also home to several of Washington's literati, including mystery novelist Robert Andrews, who lives down the block. Andrews likes the feisty little pug, and put Figaro in his 2002 novel, *A Murder of Promise*.

From pages 1–2:
Figaro sniffed and peed his way up the hill toward R Street, while Hoagland sipped her coffee and enjoyed the early-morning luxury of thinking about nothing in particular. Suddenly, a violent tugging on the leash snapped Hoagland out of her reverie. The small dog had disappeared into a tall hedge.

"Come here." She yanked at the leash.

Figaro whined and struggled farther into the hedge.

A cat or a squirrel, Hoagland thought.

Until she saw the blood on Figaro's muzzle.

Lucy, 12

As a pup, Lucy would consume things that were not technically food: shoes, sofa cushions, drapery, and so forth. Exasperated, Linda bought a popular obedience-training book titled *Why Good Dogs Do Bad Things*. Lucy ate it.

"I boxed up the remains," says Linda, "and sent it to the authors, with a note that said, 'What now?' I never heard back."

Over time, Lucy gave up her gluttony. She became well-behaved, if a bit of a wimp. On walks she keeps her distance from larger dogs, fiercer dogs, aggressive dogs, or dogs she just doesn't know. This is where the car comes in.

Lucy is never happier than when she is in a car—her head out the window, drool flying in the whipping wind. This is a joy known to many dogs, but Linda believes that with Lucy, the experience goes deeper. It's about being in a juggernaut.

"With two thousand pounds of metal around her," Linda says, "Lucy feels protected and empowered. As we're riding through the streets and we pass dogs twice her size, she'll bark and growl and snarl. In that car, Lucy can take anybody."

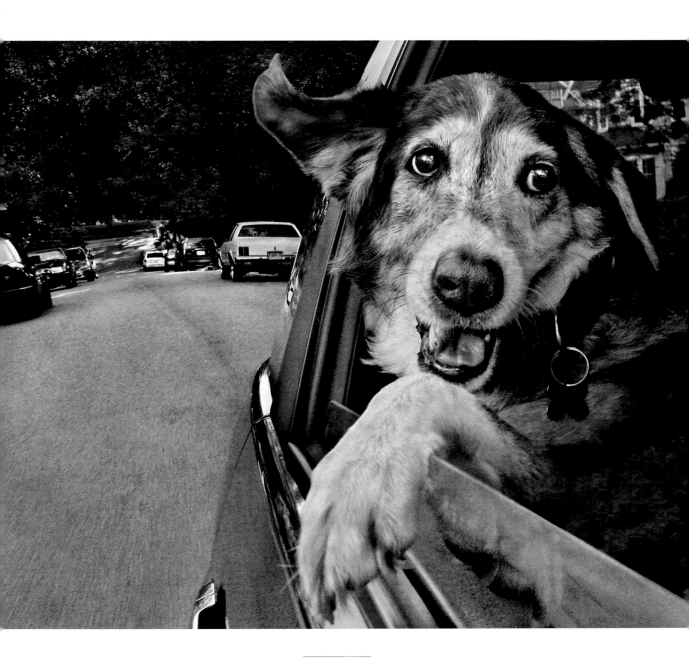

Cleopatra Sunflower, 13

As a puppy, Cleo the basset hound belonged to a 13-year-old girl in a substance abuse program. The deal was that the girl could keep the dog for as long as she stayed off drugs.

Cleo was not yet a year old when she went up for adoption again. Michael and Anita kept the name the child had given her because, says Michael, "it just seemed like the right thing to do."

Once a therapy dog, always a therapy dog. "One day when Cleo and I were out walking," says Anita, "we saw a sixteen-year-old neighbor of ours sitting on the sidewalk, crying. Cleo put her paws around the girl's neck. The girl said, 'Omigod, your dog is hugging me.'"

Cleo's greatest talent was discovered by Anita's mom, Asha, a few years ago:

"I was listening to opera," says Asha. "It was 'Casta Diva,' from Bellini's *Norma.* I was singing along. Suddenly Cleo was, too."

The thing is, this wasn't the random baying of a hound. "When I went high," says Asha, "Cleo went high. When I went low, she went low."

The family has encouraged Cleo's operatic career. She'll sing on command now.

"She's a fine mezzo," says Asha.

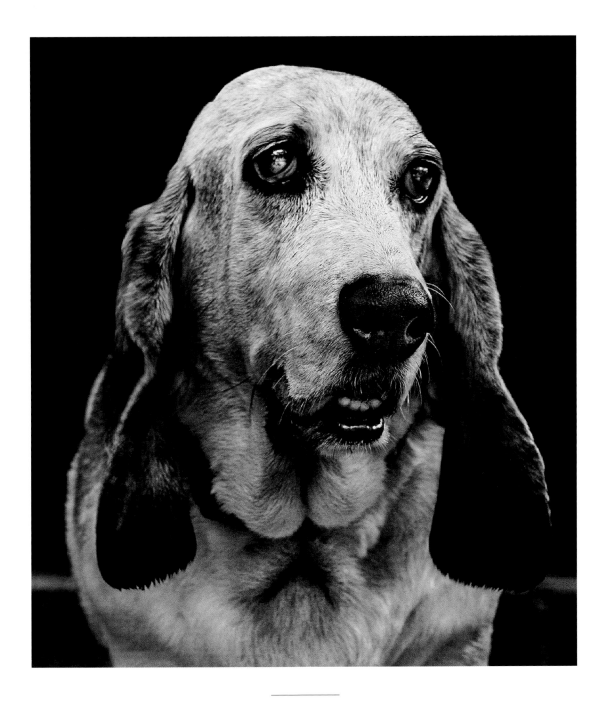

Vipper, 11

Vipper doesn't like the backyard pool all that much. She's kind of scared of it. Whenever Steve or Marjorie drops her into the deep end—and they do it a lot, over her objections—Vipper paddles as fast as she can for the safety of the steps.

Perhaps you are thinking unkind things about Steve and Marjorie. Don't make judgments until you hear the rest of the story.

Years ago, they had another Jack Russell terrier. His name was Billy Bunter. One night they found him in the pool, along with a raccoon. Both had drowned. Steve and Marjorie believe that the dog was fighting the raccoon, and both fell in, and neither knew how to get out. Billy was floating just inches from the steps.

And so as a ritual, at the start of every summer, Vipper gets thrown into the deep end, once, twice, four, six times, as many times as necessary, at different locations, in different positions, until it is clear she will always know where safety lies. It's a yearly ordeal, born of love and loss.

Indy, 10

Cheryl was watching an old video of a greyhound race in Florida. In the home-
stretch, one dog burst from the pack and made a furious run at the leader.
Need Fo Speed took second place.

"I turned around," says Cheryl, "and here was Indy next to me on the sofa
in a nest of pillows. I'm thinking, how can this be the same dog?"

It was. Need Fo Speed, champion racer, is now Indy, champion couch
tuber. Cheryl adopted him at 4, after his legs gave out.

"It was amazing to watch him transition to a pet," Cheryl says. "He didn't
know what a belly rub was. He didn't know how to give kisses."

Indy had never even had a real name. He'd never had anyone to love him.
Now Indy will always come to sit at this window, two minutes before Cheryl
comes home. Somehow he just knows.

At night Cheryl races Indy upstairs. The winner's the one who touches the
bed first. The race begins when Cheryl takes off, so Indy must come from
behind, as is his custom.

"When he wins, he knows," says Cheryl. "He struts."

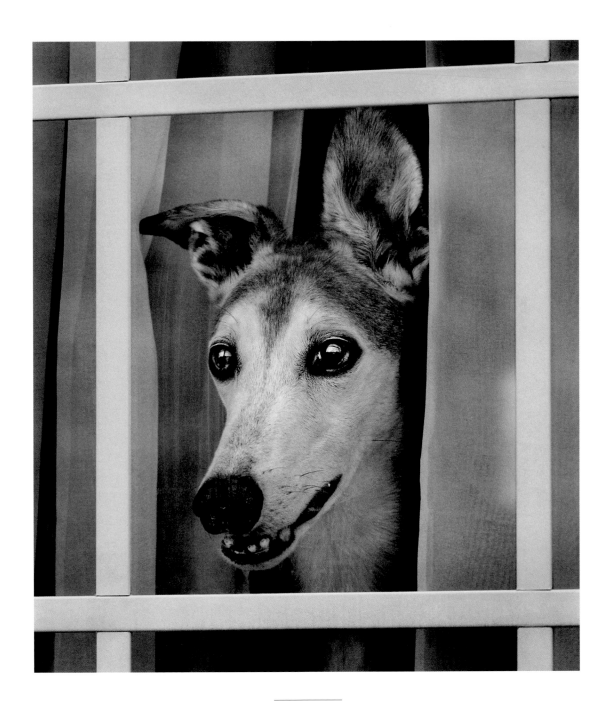

Smokey, 16

Tactfully we inquired of Jessica whether she knew that her dog looks exactly like a Wookiee. An uncomfortable silence ensued; we sensed we had erred.

"Actually," said Jessica, "I'm told Smokey looks more like an Ewok."

Smokey began her life named Onyx. When Jessica's family adopted her at the age of 8, time had turned the obsidian dog gray. A name change was in order.

Smokey's most dramatic characteristic appears to be profound gender confusion.

"She wants to be a boy," Jessica says. "She not only lifts her leg to pee, but she'll pee every five feet to mark her territory."

That's unusual, but not *that* unusual, we said.

"She steals my panties but not my boyfriend's undies."

Odd, yes, but hardly . . .

"She once tried to mount a cat in heat."

Okay, sold!

Max, 14

Like many small dogs, Max the long-haired dachshund is unaware that he is a peewee. One day years ago, when Max sensed that another animal was threatening Maia, the little girl in the family, he bit that animal on the nose. It happened to be a horse. No deaths ensued. The horse kept a respectful distance afterward.

There is one and only one circumstance under which this dog's formidable courage flags. Dog owners need not read the next paragraph. They know where it is going.

"At the vet, he's a crying, whining, shivering, howling, squirming, terrified mess," says Mitch.

These days Max may have slowed a bit, but his pugnacity has not left him. It has morphed a little, into the demanding cantankerousness of advanced age.

"He's crotchety, like an old man," says Maia. "When he needs to go out, he gives you one warning. You've got ten seconds, then it's too late."

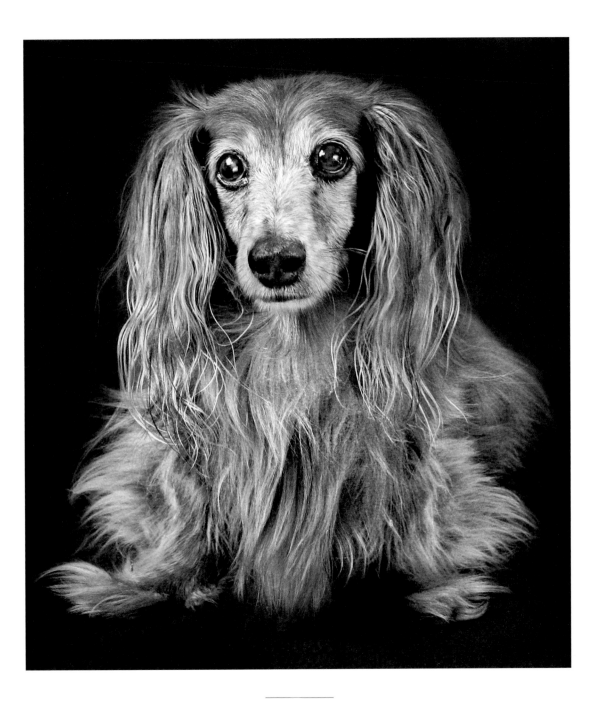

Katie, 11

Katie is one of six dogs living idyllic lives with Sally, an internationally acclaimed photographer, on her 400-acre farm in rural Virginia. Here's Sally:

"We don't like Katie very much. She has a lousy personality."

Well, see, this is a book about how old dogs are terrific, and—

"The greyhound rescue people said, 'Don't take this one.' Her previous owners gave her up because something didn't click with them and the dog, and she ended up [doodying] on their pillows, and not just once. We took her."

She must have some redeeming quali—

"She has this untrusting, furtive, sneaky personality. We think she's the one who's been peeing on the dining room rug. It'd be just like her."

But there must be—

"You could knit a sweater out of what she sheds in one day. Her breath is apocalyptically repellent; when she's sleeping, she can stink up the whole room. She loves horse [doody], dives into it with relish, and then [passes gas] because of all the horse [doody]."

Do you love her?

"She's never mistreated and she's never unhappy. Good enough?"

Good enough.

Mr. Stinky, 14

"His real name is Luigi," says Giuliana, "but I call him Mr. Stinky because he loves to get dirty. People think Yorkshire terriers are prissy, but they forget the 'terrier' part. They were bred to go into mines for rats, and that kind of gives you an attitude. So Mr. Stinky gets a bath a week. Doesn't like it much."

Mr. Stinky came out smelling like a rose one day a few years ago in an incident at an outdoor café.

"I had the dog on my lap," says Giuliana, "and this guy reached over to steal my handbag. Mr. Stinky buried his teeth in the guy's arm and wouldn't let go. There was blood.

"So a cop shows up. I pry Mr. Stinky off the guy. And the guy is yelling that he wants me arrested for having a vicious dog.

"The police officer took one look at the man and said, 'I could haul you in, but I'd hate to think what the guys in jail would do to you when I tell them that you tried to get a woman arrested because her six-pound dog attacked you.' "

The would-be purse snatcher just shuffled away.

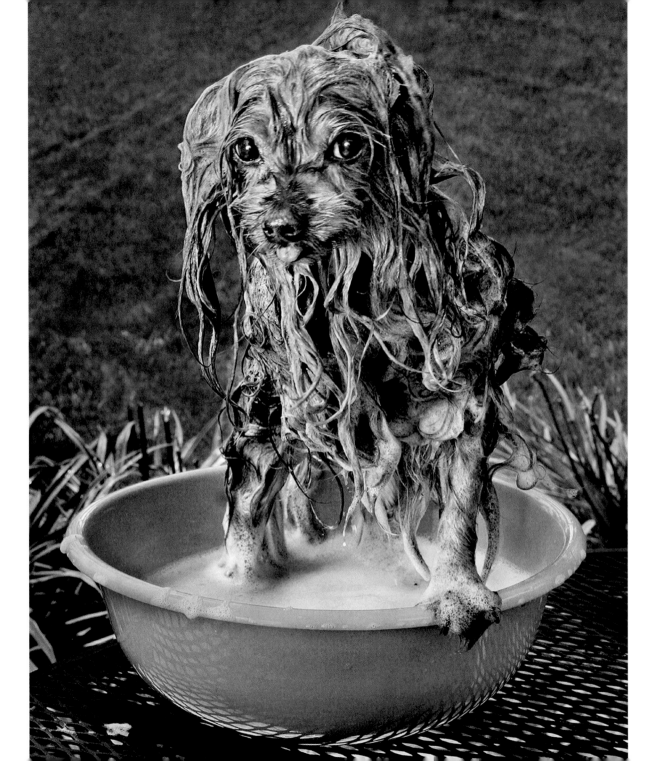

Winston, 13

Bearded collies come from Scotland. So does Sean Connery.

Let the record show that one day a few years ago, Winston the beardie met and charmed his famous countryman on the streets of New York. You might say there was an immediate Bond between them. Connery hunkered down, right there on Park Avenue, better to encounter Winston face-to-face, eye to . . . fur.

Establishing eye contact with a bearded collie can be tricky. Its eyes are hidden behind generous bangs, a remnant of the breed's days on the moors, herding sheep with verve and gumption, their eyes shielded from the strong winds. Photos of champion beardies are usually eyeless.

So Pat wasn't thrilled that we kept brushing the hair from Winston's eyes for this picture. We insisted. She protested. We won. Aren't you glad?

Lido, 16

We'd like to have shown you Lido doing her Big Trick, because it's a pants-wetter. But she doesn't do it anymore. When Penelope used to say, "Stand on your head, Lido," Lido would. She'd press her cheek to the ground and raise her bum high in the air until her rear paws were on tiptoes.

Unfortunately, Lido has weak lungs, and those half-headstands made her cough and wheeze. Penelope, a professional dog trainer, had to do the unthinkable: She had to un-train a trick.

Penelope got Lido nine years ago, after the dog's doting first owner died of AIDS. Then Lido lost her best dog friend, Macy. When she moved in with Penelope, she became friends with Penelope's dog, Georgia. Then Georgia died.

"Lido's lost a lot," says Penelope, "but she's remained practical. She's rooted, centered, and purposeful. She knows there's always someone to love."

Lucky, 13

When customers plop their laundry on the counter at Mrs. Park's Dry Cleaners, they seldom make eye contact with Mrs. Park. Their attention is distracted by the little dog eyeing them expectantly from below, through the clothes-basket pass-through.

Many of the regulars bring treats for Lucky, who is something of a gourmand.

"They bring cookie for him," says Mrs. Park. "They bring hot dog for him. They bring hamburger for him. They bring sandwich for him. They bring his favorite, pepperoni. They don't give anything to me. Just him."

Lucky has the run of the establishment. He follows Mrs. Park from the counter to the desk to the sewing area. He has a little bed in each place.

As customers leave, Mrs. Park once again becomes the invisible woman.

"They say, 'Good-bye, Lucky!' They say, 'See you later, Lucky!' They say, 'I'll miss you, Lucky!' They never say good-bye to me. They don't even know my name."

Toot, 14

Toot always seemed wise. But as her head slowly frosted from nose to ear, her black-rimmed eyes, though befogged with cataracts, became more prominent and penetrating. "They pierce you," says Monika. "It's like she's looking not *at* you, but *into* you."

Three years ago, when Koori the rottweiler arrived in the house as a puppy, Toot taught her the rudiments of being a dog. Now Koori returns the favor the way dogs do, with the reassurance of her presence. We tried to get a candid photo of Toot alone, but Koori could not be coaxed away.

Conventional wisdom holds that dogs don't understand mortality, and that may be. But as Toot's vigor slowly ebbs and her walk slows and those eyes dim, Koori remains always at her side, as if each moment is tender.

Dodger, 13

Just another day in the life of Dodger, the testy Westie:

4:00 P.M. Photographer arrives at house with photo assistants, daughters Sophia, 11, and Valerie, 8. Dodger bites photographer on foot. Teeth penetrate shoe. Owner Hilary, 24, says not to worry; Dodger is a nice dog whom people misjudge.

4:01 P.M. Dodger bites photographer on right hand. Breaks skin.

4:09 P.M. Photo session begins.

4:11 P.M. Dodger bites photographer on left hand, strikes bone. Massive bleeding ensues. Photo assistants begin to cry.

4:12 P.M. Hilary escorts photographer to bathroom to try to stanch flow of blood. "Dodger bit the photographer," Hilary informs father. Father, not looking up from newspaper, says, "Uh-huh."

4:17 P.M. Blood-stanching operation still in progress. Hilary informs photographer that Dodger is not mean: "Nipping is just his way of saying no." Father informs photographer bite isn't so bad, demonstrating own Dodger-generated scars, including one from day before.

4:26 P.M. Blood-stanching operation ends semi-successfully.

4:28 P.M. Photo session resumes. Photographer takes image at right, capturing expression: "Hey, Meat. You still wan' a piece a me?"

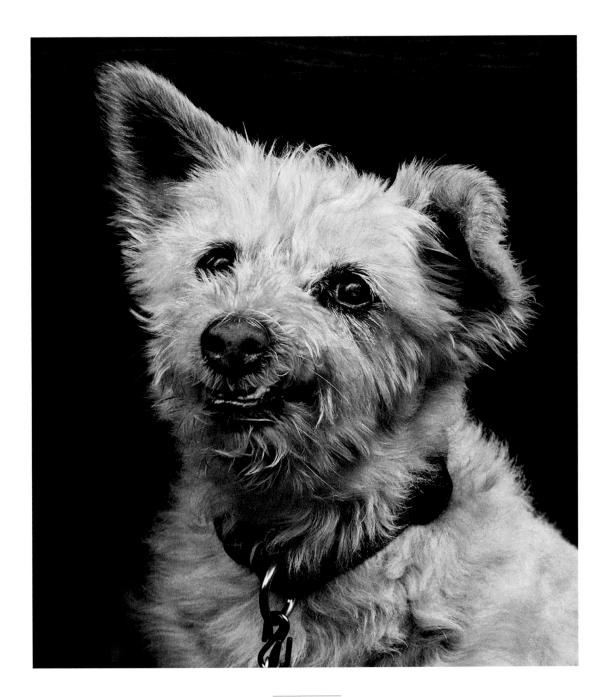

Duchess, 10

No dogs in costumes, we promised ourselves; this would be an implicit contract with readers, a warranty against preciousness.

Then we encountered Duchess, the miniature pinscher. Shooting Duchess sans duds is unthinkable, like shooting Groucho without cigar, Woody without glasses, Carmen without the silly hat. Actually, it's *exactly* like Carmen without the silly hat.

On Halloween, says Dottie, "Duchess has been a ladybug, a skunk, a bunny rabbit, a mariachi dancer, Peter Pan, and the sorcerer's apprentice." For winter wear, "Duchess has a leopard-print jacket as well as a harlequin, a houndstooth, a Burberry-type jacket . . ."

It's easy to pass a min-pin by in the street; they are square, generic-looking little dogs, reserved and a bit aloof. It's only when she's outfitted, says Dottie, that Duchess gets noticed, and Duchess notices that. "She likes it. Then she acts like an aristocrat, as though people are her subjects."

Dottie, how much have you spent on clothing for Duchess?

"Easily six thousand dollars."

So, ah . . .

"Yes, it's a little embarrassing."

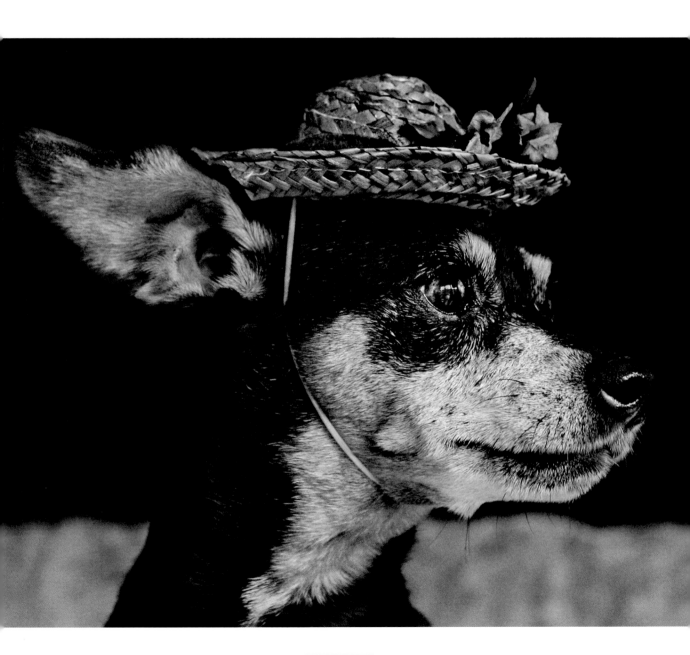

B.B., 13

We outlive our dogs. That's just the way things are, except when they aren't.

When you die, you're gone. Except when you aren't.

B.B. arrived as a gift to ease inconsolable grief. Naomi the nurse had lost both her dog, who was hit by a car, and Mr. Burns, the sweet old man she'd been caring for. As a kindness, Mr. Burns's daughter gave Naomi a Pekingese puppy.

Ten years later Naomi died. Only one of her daughters could care for the dog, and she didn't want to.

"I'm single, unattached, and a free spirit," says Beulah. "I didn't want to be tied down."

She took the dog. And here's what Beulah discovered: In B.B., her mother still lives. Nice old Mr. Burns is in that little dog, too. So is Jo Nell, Beulah's sister who died of cancer not long ago; B.B. used to play with Jo Nell's dog. The memories are all entwined. There's a lot of family etched in that flat little face.

"When B.B. is doing something he shouldn't be doing," Beulah says, "I tell him, 'Mom would not have approved, young man.' I can't tell you how good that makes me feel."

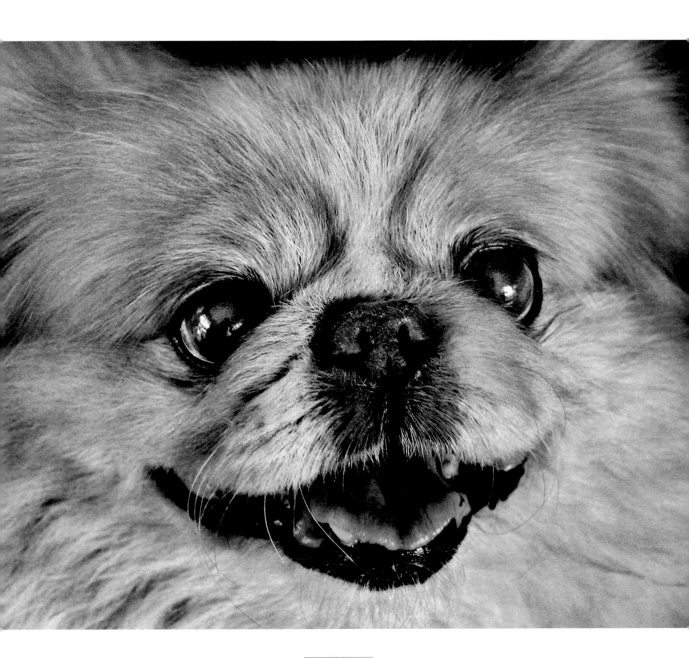

Sasha, 13

Sasha spent the first 11 years of her life in Malawi, where she lived with Pam, who headed a humanitarian organization. Sasha chased wild monkeys, mongooses, chameleons, and hornbills the size of small wolves. If the geckos were too slow, she dined on their tails. But her favorite prey were insects. She would leap to grab mosquitoes off the ceiling, flies off the furniture, and wasps in the air, one of which nearly killed her. Important lesson learned: Chew wasp before swallowing.

Now in her declining years, Sasha is a city dog. She needs a ramp to get into Pam's car, and her walks are slow and methodical.

Bug eating? "Only if one flies right into her mouth," says Pam. "It happens sometimes. To her utter delight."

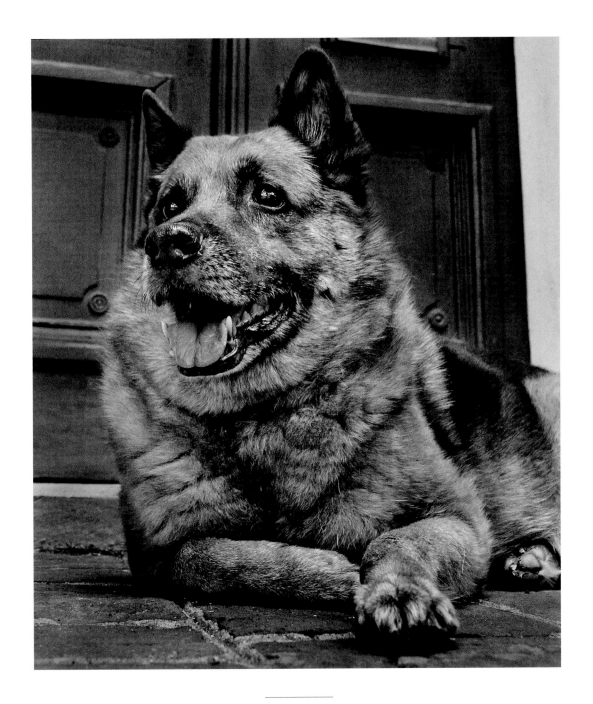

Rudder, 11

Rudder got his name on the perfectly reasonable theory that a Portuguese water dog might like to, you know, swim. Frank and Julia envisioned their puppy performing feats of aquatic skill just like his Iberian ancestors, who would steer with their powerful tails as they wrangled fishing nets in the ocean.

"Then we took Rudder to the beach," says Julia. "When the waves rolled in, he ran."

So Rudder settled down to land-based duties. These consisted mainly of looking handsome, which he did splendidly until somewhat recently, when he began to go bald on the top of his back. This compelled daughter Mara to note mischievously that Rudder seemed to be emulating Dad.

Everyone laughed at the audacity of this uncharitable comparison—in dog years, Rudder is a lot older than Dad, not to mention an entirely different species—until the vet's diagnosis came back. Rudder suffers from irreversible follicular dysplasia, which is a fancy term for . . . male pattern baldness.

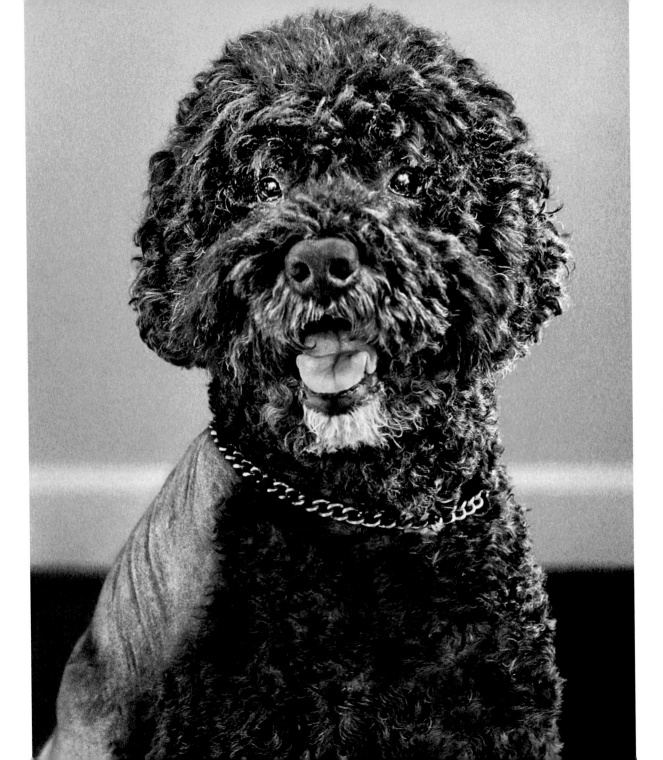

Sparky, 12

LIZ: We got her at the pound when she was five. She had just had puppies. She was short and wide, and her stomach was literally on the ground. She was the homeliest dog I had ever seen in my life. I knew no one else would take her and she'd die, so I just opened the car door and told her to get in.

DOUG: We had a hard time getting the weight off her.

LIZ: She's a pig!

DOUG: The first morning, she climbed onto the breakfast table and polished off a tray of bagels. We really restricted her diet, but she kept gaining weight.

LIZ: It took us a while to figure out what was going on.

DOUG: Every night she'd wake me up at three A.M., and I'd let her out in the back-yard.

LIZ: She'd take a long time.

DOUG: Turned out she was going next door, walking into our neighbor's house through the dog door, and eating all their dog food.

LIZ: It's taken care of now. Sparky is trim. And the most loving creature I have ever known.

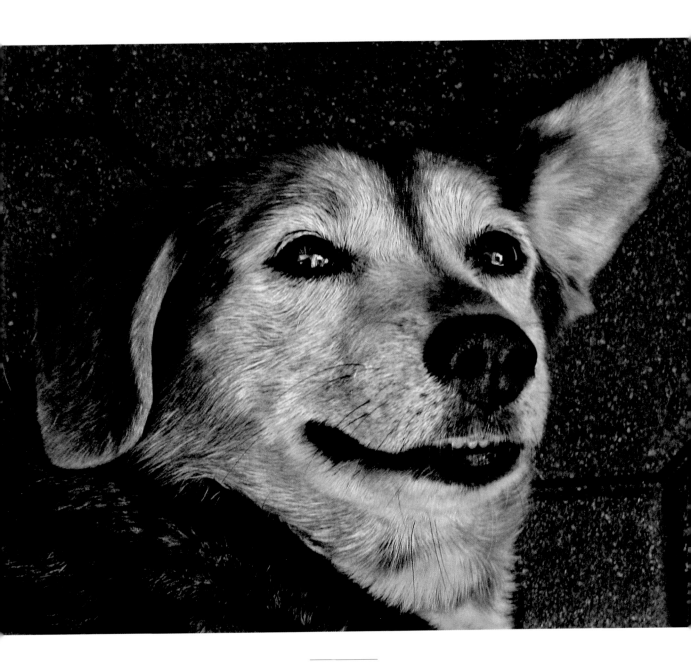

Kelly, 16

Like old cars, old dogs eat money. Kelly chews and swallows.

"Without even a single opposable thumb," says Joan, "this dog once took my wallet off the sofa, extracted my real estate license and a twenty-dollar bill, and ate them both. I found her with a one-dollar bill hanging out of her mouth."

Kelly's belly is a cornucopia of crap. When a large, suspicious mass showed up on an abdominal X-ray, a surgeon opened the dog up, expecting the worst. What she found inside filled a one-quart Ziploc bag and included sticks, leaves, mud, rubber bands, candy wrappers, and cellophane.

You may wonder how Kelly the springer spaniel has managed to live three years beyond the breed's expected life span. So does Joan.

"Kelly sleeps with me. Every morning, the first thing I do is put my ear to her chest to make sure she's still breathing."

Jake, 16

As you can see, Jake eventually grew into his feet.

You are looking at the faces—young and old—of a gentle, docile dog who is great with children. And that's a good thing, because twelve grandchildren come to visit Jake, and he lives half a block from an elementary school. That's a lot of little noses to lick; Jake tries for every one.

Dogs don't understand photographs, so Jake probably isn't engaged in any sort of bittersweet reverie here. He's not being taunted by this image of his younger self. He isn't wistfully contemplating the heartless assault of time.

You are.

The End

GENE WEINGARTEN, pictured here with Murphy, his Plott Hound, is a nationally syndicated humor columnist and a staff writer for *The Washington Post*. He has written two books, *The Hypochondriac's Guide to Life. And Death* (Simon & Schuster, 1998), and *I'm with Stupid* (with Gina Barreca; Simon & Schuster, 2004).

In 1987–88, Weingarten was a Nieman Fellow at Harvard University.

In 2008, he was awarded the Pulitzer Prize for feature writing.

Weingarten lives in Washington, D.C. He has instructed his family that he wishes to be buried in Washington's Congressional Cemetery, because it allows dogs to run free. He wants his tombstone to read only: "Gene Weingarten, a funny man who loved dogs," and to be carved in the shape of a fire hydrant.

MICHAEL S. WILLIAMSON was born in Washington, D.C., and raised in several foster homes before settling with a permanent foster family in his early teens. He joined *The Washington Post* in 1993. He previously worked at *The Sacramento Bee* (1975–1991) and taught at Western Kentucky University (1991–1993).

Williamson has covered a variety of global events in the last thirty years, including the wars in El Salvador and Nicaragua, the Philippine revolution, strife in the Middle East, the Gulf War, and conflicts in Africa and the Balkans.

In 1994 he won the Crystal Eagle Award, a national award recognizing photography that has had a documented effect on society. He won the award for a fifteen-year project on homelessness in America. His work on the homeless yielded three books, including *And Their Children After Them* (coauthored with Dale Maharidge), which won the Pulitzer Prize for nonfiction in 1990.

Another book (also with Maharidge), *Journey to Nowhere: The Saga of the New Underclass*, was optioned by HBO Pictures. Two more recent book collaborations with Maharidge produced *Homeland*, which was released in 2004 in the United States and Italy in 2005, and *Denison, Iowa*, which was published by the Free Press this past September. Another book project, *The Lincoln Highway* (with Michael Wallis), was published by W.W. Norton & Co. in 2007.

The National Press Photographers Association named Williamson Newspaper Photographer of the Year in 1995. In 2000 he won his second Pulitzer for coverage of the conflict in Yugoslavia and was named White House News Photographers Association Photographer of the Year, also in 2000.

In the past year, Williamson has taken on roles at *The Washington Post* ranging from assignment editor to daily picture editing, while shooting assignments in between. He lives in Silver Spring, Maryland, with his daughters, Sophia and Valerie.